IMAGES
of America

STANHOPE
AND BYRAM

IMAGES
of America

STANHOPE
AND BYRAM

Jennifer Jean Miller

ARCADIA
PUBLISHING

Published by Arcadia Publishing
Charleston, South Carolina

Printed in the United States of America

Library of Congress Control Number: 2014930473

For all general information, please contact Arcadia Publishing:
Telephone 843-853-2070
Fax 843-853-0044
E-mail sales@arcadiapublishing.com
For customer service and orders:
Toll-Free 1-888-313-2665

Visit us on the Internet at www.arcadiapublishing.com

This book is dedicated to those who have made and continue to make the communities featured here the positive places that they are today.

CONTENTS

ACKNOWLEDGMENTS

I cannot make it through each and every day without the love and guidance of my God above, and I thank Him for empowering me with the abilities and love to write, research, and create.

To my family and, most especially, Jason, Christopher, Amanda, and Jadin, for all your love and support: I love you all and am so blessed you are always cheering me on.

To Katie Owens, Rebekah Collingsworth, Katie Kellett, and Tim Sumerel of Arcadia Publishing, thank you for your guidance.

I am grateful to locals who love history and who have helped to make this book possible. Stanhope resident and Sussex County freeholder George Graham, who also embraces chronicling historical events and has been an amazing source of support and connections; Ros Bruno, innkeeper of the Whistling Swan Inn; Wayne T. McCabe, trustee and historian of the Sussex County Historical Society; and historian Dr. Bill Truran, have all been an incredible support network and I am very appreciative to them all.

The expression "Strangers are friends you haven't met yet" applies in many ways to my experiences in authoring this book. The project has introduced me to many wonderful people who were willing to share their time and images. I have been blessed to "meet" (some not in person yet) many Byram residents (some now expats) who helped with this project and shared their personal photographs and anecdotes with me. I must first thank Dean Giering for introducing me to the Facebook group "I grew up in Byram Twsp, NJ." Through Dean's foresight in connecting me to this group, I have had the opportunity to connect online with wonderful people, including Bob Donlan, Daniel Sutton, Sandra Dodd Hand, Winnie Slachetka, Mike D'Angiolillo, Francine Baldwin, Fred Fry, Jason Fry, Deborah Gilkeson, Carlene Thissen, Tina Honthy and many more.

I would also like to thank Dave Rutan of DLW-SussexBranch.com for his guidance.

I am grateful to and for all of you for helping me to make this project possible.

INTRODUCTION

In 1798, the former Newton (once known as Newtown) Township became further divided. In the old boundaries of the colonies, before America fully became independent from the United Kingdom, New Jersey was divided into east and west territories. Newton Township was then a part of Morris County, established in 1751. That footprint now comprises current-day Morris, Sussex, and Warren Counties.

In February 1798, the New Jersey General Assembly added Newton Township onto its roster of 104 townships. By 1864, this township was fully dissolved and, after that, its territories formed other towns, among them Wantage Township (1754), Hardyston Township (1762), Frankford Township (1797), Byram Township (1798), and Sparta Township (1845). In 1864, at Newton Township's formal dissolution, the municipalities of Andover Township, Hampton Township, and the Town of Newton were formally created.

Byram Township, known as "The Township of Lakes," is now a thriving bedroom community in Sussex County. The township is known today for its scenic aspects, including those beautiful and active lake communities, its picturesque trails previously frequented by the Sussex Branch Railroad (from 1848 to 1966), and its local parks (including sections of Allamuchy Mountain State Park) and recreational fields. Byram was also known for its mining industry, including, uranium, limestone, and iron ore.

Waterloo Village is another Byram Township jewel. Once a stop along the Morris Canal, the colonial/19th-century village was preserved in the 1960s for tour groups of all kinds, especially schoolchildren, who were able to witness how the villagers lived in those days. Visitors watched those who volunteered their time by dressing in period costumes and reenacting the many roles and services that the village was able to provide to those in previous times. From a general store, to the blacksmith shop, to the mills, and more, it was an opportunity to learn about and connect with living history. At one time, Waterloo Village hosted top concert acts on its grounds.

However, after years of a private foundation managing Waterloo Village, the New Jersey Department of Environmental Protection (NJDEP), Division of Parks and Forestry, assumed the role of providing $600,000 toward restoration efforts in 2007. In 2010, the Division of Parks and Forestry reopened Waterloo Village for educational tours. Among the sites were an emulation of a Lenape Indian village, a log cabin on the property from 1825, and the Smith's Store, dating from the 1800s.

The Friends of Waterloo Village, a nonprofit group, has helped with fundraising and restoration efforts. Through their efforts, the Friends have helped to host various events, including the Harvest Moon Festival, and have successfully raised monies for repairs on the gristmill and Smith's Store roofs. The group is working toward repairs for other sections of the village, including the mule bridge.

Out of the Township of Byram emerged another community, the Borough of Stanhope. Originally an unincorporated village within Byram Township, Stanhope officially became a

borough in 1904. A borough is one of a number of types of municipal government forms in New Jersey, allowing communities like this small corner of Byram Township to emerge as its own independent entity.

Stanhope's history is reflected in one of its oldest building, which predates Byram's official incorporation as a township. The Stanhope House, with an extensive history as a private home, tavern, stagecoach stop, post office, a historical blues club, and more, dates to about 1794. The king of the United Kingdom, George II, reportedly issued the original deed to the home in 1752 for Lord Stanhope (likely Philip Stanhope, 2nd Earl Stanhope).

Stanhope Borough especially thrived in the mid-1800s, when it became a stop along the Morris Canal. The canal is now defunct, but at one time it was one of the world's marvels in terms of canal construction. Its complex network of locks and inclined planes served as a model for other canals. The Musconetcong River became a valuable source to help fuel industry in town, as did Lake Musconetcong, which was created to feed the Morris Canal. Stanhope was known as a vital community for the iron industry. The Singer Manufacturing Company, one of the best-known companies for sewing-machine manufacture, had its facility in Stanhope.

Stanhope grew around its activities along the Morris Canal route. Tenants worked to fuel the iron furnaces in the complexes and maintained the canal. From there, Stanhope evolved, adding services in town such as stores, a school, a tannery, mills, a blacksmith shop, churches, and more.

Canal travel, however, became cumbersome, and the railroad began to make strides as a means of both passenger and cargo travel. The Morris Canal experienced its heyday from the 1820s through the 1860s, with trains outmoding canal boats by the 1870s. By 1923, the State of New Jersey assumed responsibility for it; most of the canal was dismantled by 1929.

Today, sections of the Morris Canal are being preserved and its history cherished, with celebrations along portions of the former waterway to teach locals about how life proceeded during those golden years. Many of the former mule paths have been refurbished into walking and biking routes. The waterways themselves have been cleaned in some locations, and wildlife, such as fish, turtles, and birds, now calls these waters home.

The Borough of Stanhope, like the Township of Byram, has become a bedroom community with a number of sections. Some residents reside in the historic downtown, living in quaint, Victorian-style homes that nod to yesteryear. Lake Musconetcong provides an enjoyable recreational community for its residents. Other neighborhoods and sections of the Borough of Stanhope have also sprouted up over the years along the community's hillside, writing new chapters in the municipality's history and further evolution into what is known as the "Gateway to Sussex County."

Today, close to 8,400 residents call Byram Township home, and more than 3,600 live in Stanhope Borough.

One

THE MIGHTY
MUSCONETCONG AND
MORRIS CANAL

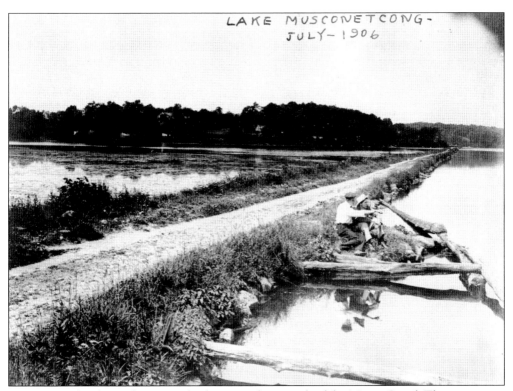

In 1906, two locals sit adjacent to the former mule towpath of the Morris Canal. They are gazing and pointing toward something of interest within the unused waterway, while the canal captures their reflections. The idyllic lake behind them was transitioned into recreational use following the Morris Canal's height of popularity as a mode of transport. (Courtesy of George Graham.)

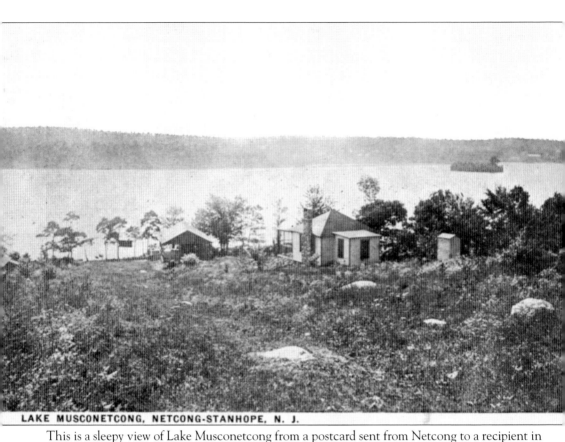

LAKE MUSCONETCONG, NETCONG-STANHOPE, N. J.

This is a sleepy view of Lake Musconetcong from a postcard sent from Netcong to a recipient in Old Forge, New York, in 1930. The card references travel in a new automobile, a luxury during the height of the Great Depression, and perhaps offers a glimpse into the life of the sender. Luella H, the sender, writes of driving from New York City to the Stanhope area in the car, which "made it very comfortable riding." It is likely that Luella visited Old Forge, then made her way to Stanhope via Manhattan. The State of New Jersey assumed responsibility over the Morris Canal less than a decade prior, and Lake Musconetcong became a tourist destination. At that time, the state also received the deed to the lake. Most of the canal's towpath became submerged following the damming of the lake in 1926. The Lake Musconetcong Regional Planning Board, formed in 1990 with representatives from Morris and Sussex Counties and the state, monitors the health of the lake. (Courtesy of Ros Bruno.)

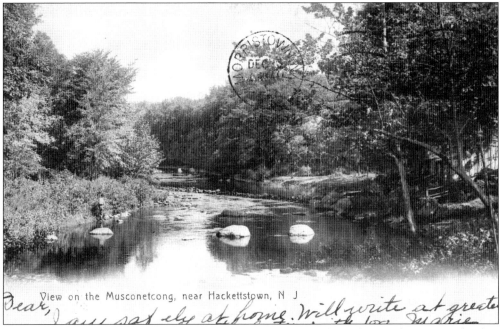

View on the Musconetcong, near Hackettstown, N J

Dear, I am not ely at home. Will write at greate . . .

Here are two vintage views of the Musconetcong River outside of the Stanhope area, the first near Hackettstown and the second near Bloomsbury. In the modern world, a ride to Hackettstown is less than 20 minutes by car, and Bloomsbury is approximately 45 minutes away. Both of these postcards date from the turn of the 20th century and reflect the times, based on the dress of the people pictured. The river has remained mostly undisturbed and preserved from those days, and it is still guarded by shady nooks and tree cover. Part of the National Wild and Scenic River System, the Musconetcong River has remained preserved because of its fish and wildlife, cultural significance, and historic value. The Delaware River, into which it flows, is also part of the system. (Both, author's collection.)

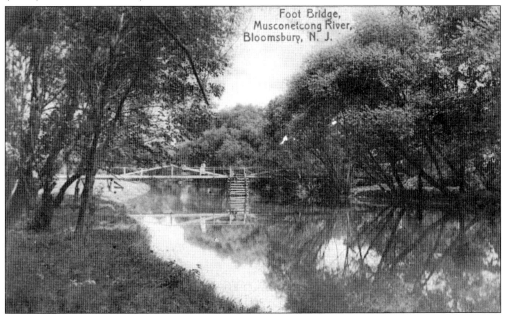

Foot Bridge, Musconetcong River, Bloomsbury, N. J.

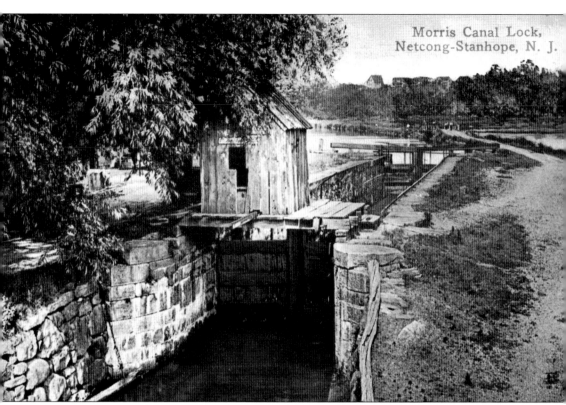

In 1916, at a time when communicating by mail was the preferred method of interaction among friends, "Mabel" from Stanhope sent this postcard to her friend Rita Lewis in Succasunna, in neighboring Morris County, about five miles away. The postcard is simply addressed to the recipient in Succasunna, with no specific mailing address, though "Box 3" is notated at the bottom of the card. The front of the card depicts one of the locks in the Morris Canal system in Stanhope. The canal locks helped to equalize the varying canal depths from section to section. There were 23 locks within the 107-mile length of canal. A lock is a small chamber in which the boat enters and is dropped or lifted within a gated area to make its way into the next adjoining stretch of water. The lock in Stanhope was known as Morris Canal Lock No. 2 West. (Courtesy of Wayne McCabe.)

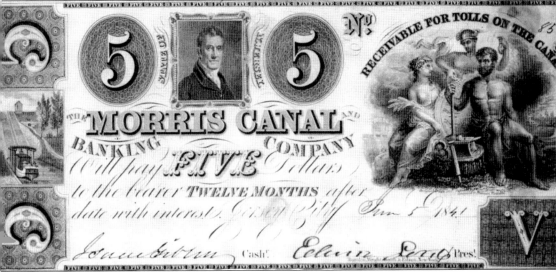

This is a $5 currency note for use in toll passages on the Morris Canal around 1841. By today's standards, this voucher would equal close to $110. The Morris Canal and Banking Company issued the currency. The company was formed in 1824 and though it was a private corporation, the New Jersey Legislature spearheaded its formation. More than $2 million was infused into the project, and the canal opened in 1832. The company was responsible for creating an artificial waterway to connect the Passaic and Delaware Rivers. The same year this currency was issued, the Morris Canal and Banking Company succumbed to financial scandals, and it was reorganized three years later. By 1870, though, the railroad began trumping canal travel, and the health of the company suffered. The state permitted the company to lease its property, and the railroad gained further ground by doing so. (Courtesy of George Graham.)

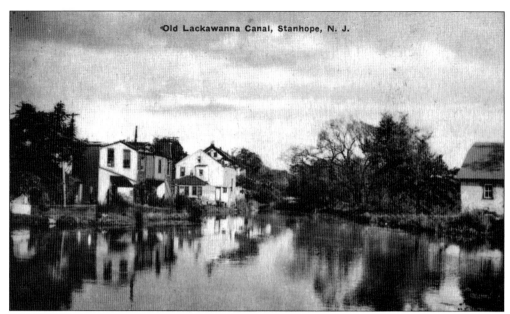

The above postcard, published in Stanhope and postmarked from the neighboring Borough of Netcong in 1944, shows the "Old Lackawanna Canal" in Stanhope. Known as the Lackawanna Railroad, the Delaware, Lackawanna & Western Railroad Company (DL&W) often paralleled stretches of the Morris Canal. The Morris & Essex Railroad, which passed through Stanhope and Netcong, began its operations in 1835, and the Sussex Railroad included Waterloo. DL&W took over Sussex in 1924 and the Morris line in 1945. The below photograph shows the canal route today, now a parking lot in downtown Stanhope. (Above, courtesy of Wayne McCabe; below, author's collection.)

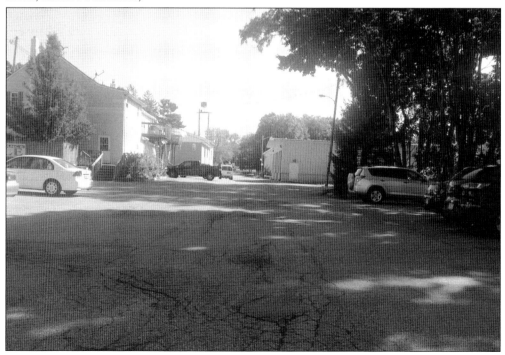

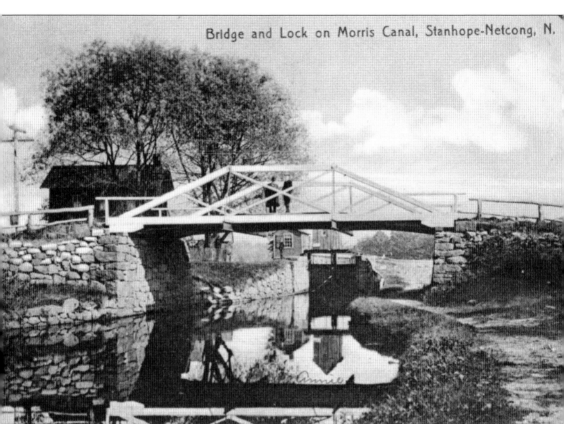

Another view of the Morris Canal along the stretch at Stanhope and Netcong depicts a bridge with two gentlemen standing on it. Bridges dotted the scenic route and allowed for foot traffic across the canal. Many of the stones laid to support the bridges and retaining walls still remain in the foundations of old homes in the area. The lock behind the bridge is potentially in use at the time this photograph was taken, since the gate is closed. This postcard was mailed to its recipient in June 1908, alerting the recipient of a visit by the sender, Annie, the following day. Though more than three million Americans owned telephones, the first cross-country call was still seven years away. It was easier for Annie to write. She also penned her name on the card's front. (Courtesy of Wayne McCabe.)

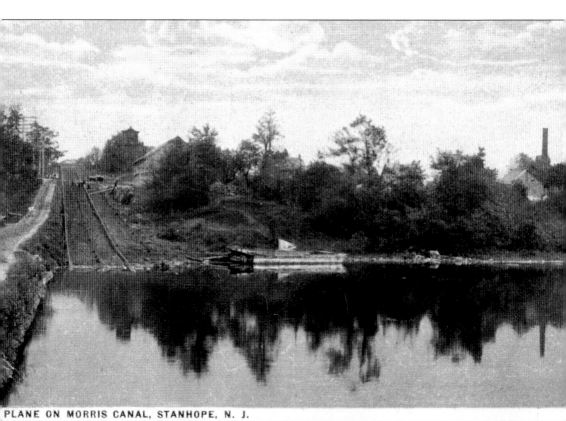

PLANE ON MORRIS CANAL, STANHOPE, N. J.

This view of Inclined Plane No. 2 in Stanhope shows what is now the route of modern-day Plane and Plane View Streets. To the far left is the mule path, known the path of Plane Lane. The inclined planes accommodated for the hilly surfaces, and mules and people dragged boats upward. In its day, the inclined plane was considered new technology, and a type of cable railway system was implemented, with tracks guiding the boats up the slopes, The Morris Canal, an engineering feat, overcame challenges to transporting items, including elevation changes of 1,674 feet. The section of canal pictured here is today the site of a field. On the far right are the smokestacks of Stanhope's local industry, the iron forges. When this card was mailed in 1921, the canal was hardly used, and it was only three years from official abandonment. (Courtesy of Wayne McCabe.)

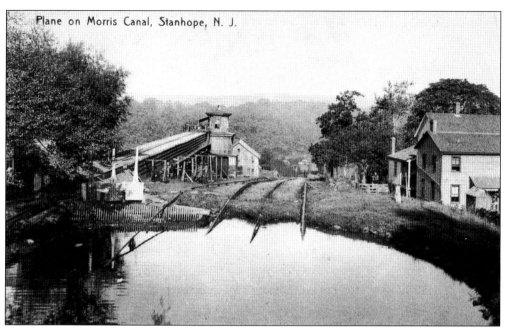

Plane on Morris Canal, Stanhope, N. J.

This postcard was mailed from Netcong to Lafayette, only about 17 miles apart and a half hour by car today. In 1907, when this card was sent, the canal was hardly in use, and talks of abandonment were already under way. Between 1900 and 1902, the tonnage transported declined by nearly 100,000 pounds. What took four days to transport by canal took only five hours by train. The above photograph shows Inclined Plane No. 2 from the top, with the view looking down toward the present-day site of Plane Lane. "Mother," who sent the card to her daughter, indicates that she arrived for dinner, which is probably referring to the midday meal. Supper was traditionally the evening meal. (Both, courtesy of Wayne McCabe.)

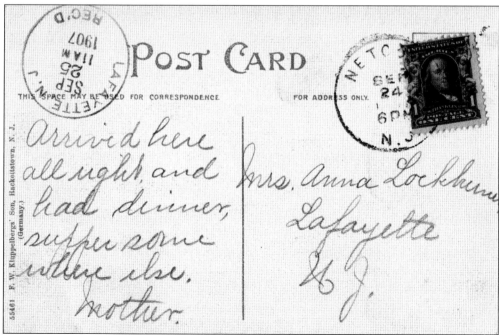

17

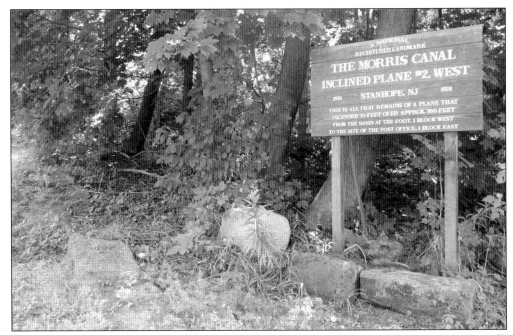

The ruins of Inclined Plane No. 2 West in Stanhope, with a few stones of the retaining wall, are shown above in 2013. Below is a view of Plane View Street from 2014. The sign (above) commemorates the "life" and "death" of the canal, like an epitaph over the century it "lived." This plane climbed 70 feet in elevation, over 950 feet from the bottom of the hill, with the canal passing by the current site of the Stanhope Post Office on Kelly Place, then known as Bridge Street. The nearby Musconetcong Iron Works, which literally fueled the industry and generated life on the canal, produced slag for the plane's walls. Where the Morris Canal and Inclined Plane No. 2 once lay is now a wooded and mostly residential area. (Both, author's collection.)

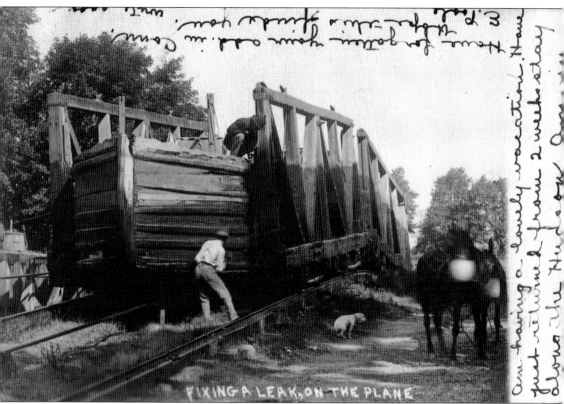

FIXING A LEAK, ON THE PLANE

A canal boat undergoes a leak repair on one of the inclined planes in 1907. To the right of this massive wooden boat is the mule towpath, where the mules and a dog stand by as the boat is fixed. The photograph provides a close-up view of the rails, pulleys, cables, and other apparatus, including a car that was utilized to haul a boat uphill. A braking system helped to temper the boat's speed as it was taken downhill. The card, mailed to Helmetta, a community in central New Jersey, was published near the Morris Canal in Hopatcong and mailed from Dover, where the sender was visiting. Dover's section of canal held five of the canal's 23 locks; the Brooklyn Outlet Lock was in the Hopatcong area. The mules were housed overnight at the foot of the plane in a special stable. (Courtesy of Wayne McCabe.)

19

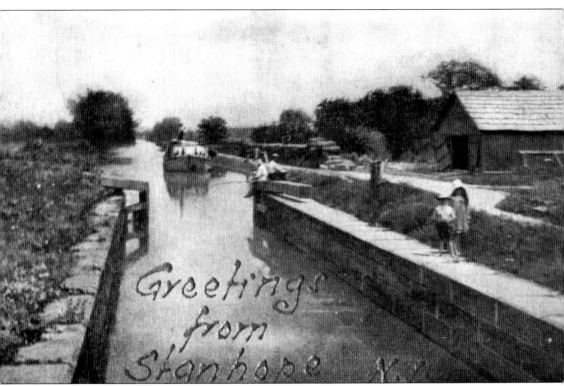

By 1908, when this postcard was copyrighted, and 1910, when it was postmarked from Stanhope, the canal was already being referred to as "The Old Canal." This card, with decorative raised writing on the front, depicts a canal no longer providing utilitarian purposes; instead, it offers leisure to its travelers. Children enjoy a barefoot walk along one wall, two men pass an afternoon fishing, and a group of people drifts along the waters by boat. The postcard's author writes to a friend, Ethel, in nearby Hackettstown, urging her to travel northeast for a visit to Stanhope. The writer indicates that she would be visiting the area for a few days and hopes Ethel can visit when she is free. Hackettstown was also an important point on the canal with Saxton Falls, Lock 5W, now a preserved section of the canal. (Courtesy of Wayne McCabe.)

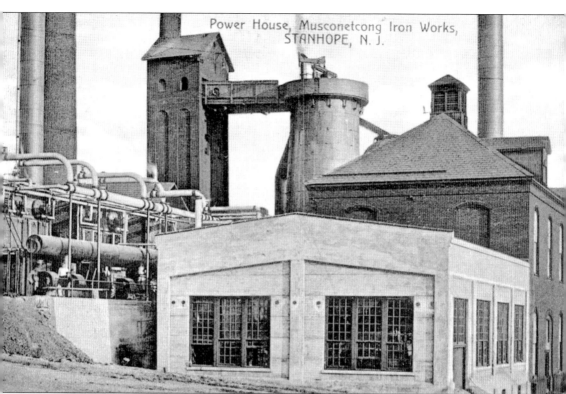

Power House, Musconetcong Iron Works, STANHOPE, N. J.

During the Morris Canal's heyday, Stanhope made its mark through its iron production. In 1901 and then in 1908, the Musconetcong Iron Works facility was chronicled in directories for United States Iron & Steel Works. It was noted that the main stack was 70 feet high and 17 feet in diameter and built in 1841. The three forges, which were 79 feet by 19 feet, were fueled with anthracite coal and coke. Ores produced there included New Jersey magnetic, Lake Superior and Cuban, and pig iron. The facility had an annual capacity of 50,000 tons. Musconetcong Iron Works was housed there beginning in 1864. Prior to that were the Morris & Sussex Company (1835), Stanhope Iron Company (1841), Sussex Iron Company (1845), and, afterward, the Singer Manufacturing Company (1902–1926). US Mineral Wool Company, still in existence today since 1875, used the furnace waste to make slag wool for insulation. (Courtesy of George Graham.)

Shown here are two current stretches of the abandoned Morris Canal. The above photograph depicts a sleepy and tranquil lagoon, which had been the turnaround location along the canal route, where the Musconetcong Iron Works and other forge companies were once located. The location shown below is adjacent to Route 183 and Stanhope's Main Street, near Furnace Park. It is hard to believe that these calm locations once hosted industrial hustle and bustle. Today, they are home to giant frogs and a variety of flora and fauna. Only by closing one's eyes could a person envision smokestacks and large canal boats shattering the tranquility of these now defunct sections of the Morris Canal. (Both, author's collection.)

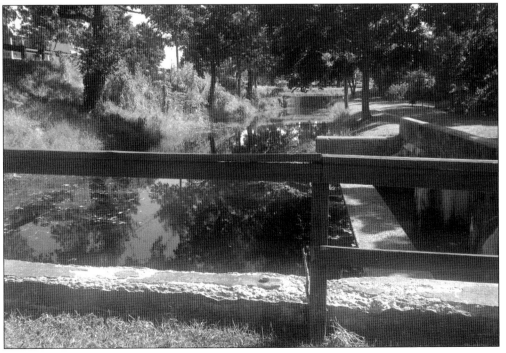

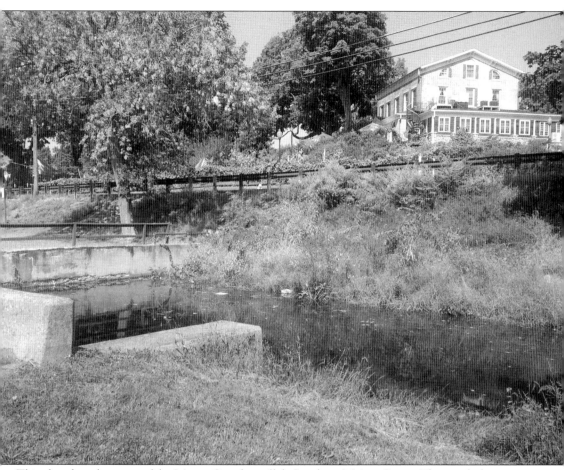

This abandoned section of the Morris Canal parallels Stanhope's Main Street. The stately former home of Robert P. Bell, one of Stanhope's prominent citizens and the president of the Morris Canal and Banking Company, is shown. Bell savored his view of the profitable waterway from the comfort of his hillside home, built in 1835. Unfortunately for Bell, banking scandals engulfed his company in 1841, and it failed. Private financiers leased the company for three years before the company was reorganized. Bell was also engaged in a lawsuit with Gamaliel Bartlett, Stanhope's first postmaster. At the time, the post office was located in the Stanhope House. Bartlett, who ran the blacksmith shop and was a founder of the canal, won a financial award in the suit Bell's company filed against him. Bell's home, now a popular restaurant, housed a few families after his tenure. (Author's collection.)

Shown here are two other abandoned areas of the Morris Canal in Stanhope Borough. The area shown above, which was at the peak of Inclined Plane No. 2, is near the rear of the post office parking lot. Some of the canal's retaining wall is still intact. The below photograph is of the "Canal Slip," also behind the post office and 6 Kelly Place. The Morris Canal and Banking Company built the stretch between 1845 and 1850; original walled sections, reinforced with modern bracketing, still remain. The preserved section, recognized as a National Historic Landmark, offers those who traverse its scenic path an idyllic walk. Silas Dickerson and his family founded the iron forges in Stanhope in the early 1780s, prior to the construction of the Morris Canal. (Both, author's collection.)

On the grasses of the banks of Lake Musconetcong and the former site of the lake's municipal beach are the tops of the walls along which the Morris Canal traversed present-day Route 183. The area along the shoreline of the municipal beach was the former site of Stanhope's "Guard Lock" No. 1 West. This lock was built of wood in 1845 and then rebuilt in 1860 with stone. This point was close to 37 miles within the canal route and elevated at 856 feet above sea level. This section of the Morris Canal was below the canal's summit. The passage was filled in with soil following the canal's official abandonment in 1924. This section of the canal led to an area previously coined the Stanhope Reservoir. The stretch of road on 183 adjacent to these canal ruins was once known as Union Turnpike Road and connected Elizabeth to Newton. (Author's collection.)

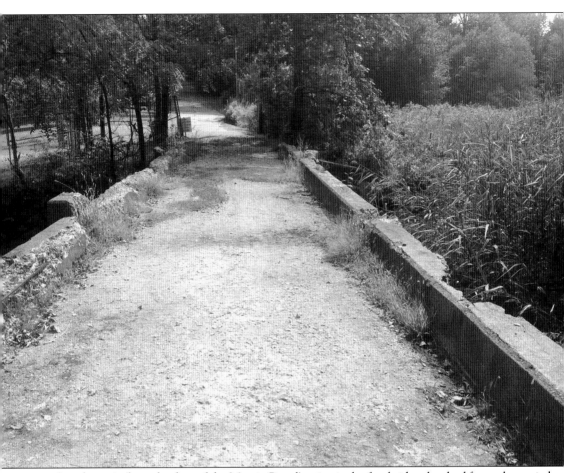

Another ruin from the days of the Morris Canal's reign is the footbridge that had formerly carried the canal's mule towpath. Over the years, the bridge has been repaired in preservation efforts on a stretch now known as Plane Lane. The bridge is at the border of Stanhope and Mount Olive Township in Morris County. A sign at the end of the bridge advises those looking to cross that it is under construction. On foot, one can now proceed into Mount Olive Township and explore walking paths along another abandoned section of the canal that has been preserved. This is most probably the spot where the photograph of Plane No. 2 West (see page 16) was taken. On the right side of the photograph, with a view that looks upward to the former Plane No. 2 West, wild grasses now grow where the canal had once flowed. The grasses tend to sway in a motion similar to how the canal waters once drifted themselves. (Author's collection.)

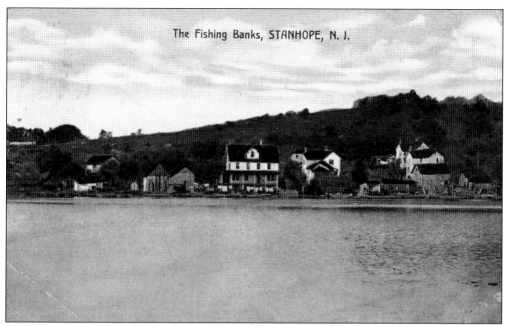

The Fishing Banks, STANHOPE, N. J.

These vintage postcards reflect the joys people experienced in the area while fishing and recreating. On the reverse of the 1910 postcard above, the sender writes of his time fishing on Lake Musconetcong. As visible on this postcard, the hillside is still dotted with farmhouses. Farming was what sustained many residents on the Netcong side of the lake. The below postcard, from 1941, captures a boy plunking a line into the waters. Lake Musconetcong was previously a boggy swamp. Then, in 1926, the dam was constructed, allowing the lake to feed the Morris Canal. The lake became an area known for excellent fishing. By the time this photograph was taken, the mule towpath and canal walls were submerged relics of the past. (Both, courtesy of Wayne McCabe.)

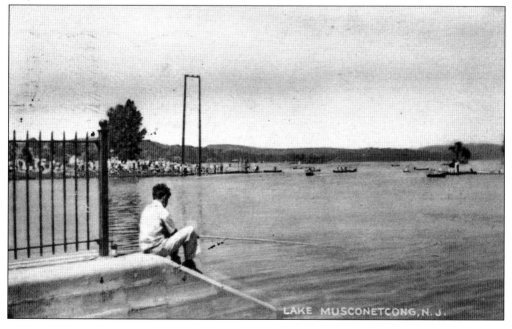

LAKE MUSCONETCONG, N. J.

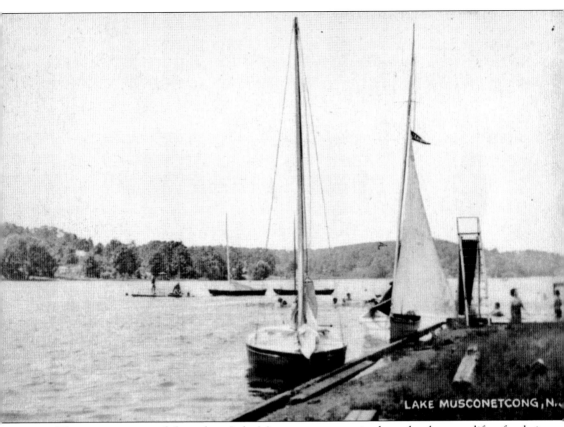

LAKE MUSCONETCONG, N.

This vintage postcard shows how Lake Musconetcong received another lease on life, after being created as the "Stanhope Reservoir" to add water to the Morris Canal. Lake Hopatcong, the largest lake in the state, flows into Lake Musconetcong, and the two lakes share the watershed area. People are seen here cooling off in the waters on a hot summer day, swimming and wading in the lake. Today, boating, fishing, and ice fishing are popular activities at Lake Musconetcong. In 1924, following the official abandonment of the canal, the State of New Jersey received the deed to the lake. Recreational activities were common in the earliest days of the lake, as is evidenced by photographs of locals enjoying activities in the water and at the various beaches on the Netcong and Stanhope sides. (Courtesy of Wayne McCabe.)

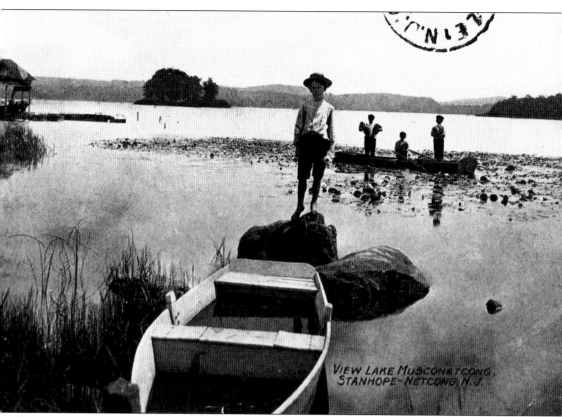

This postcard is undated, but, based on the children's dress, is likely from the earlier part of the 20th century. A young boy in the foreground and three behind him are spending a day on the lake. It is not known what the boys are holding in their arms, but they may be invasive water plant species, like the water chestnut, which made its way to both Lake Musconetcong and Lake Hopatcong. The Lake Musconetcong Regional Planning Board, which oversees issues in the watershed, has helped to spearhead volunteer water chestnut removal activities. Evidenced in this photograph is the change in safety procedures since that time. The children are not wearing life vests, and some are standing up in the boat without adult supervision. On the far left is a Horton's Ice Cream stand, which served one of the popular local confections of the early 20th century. (Courtesy of Wayne McCabe.)

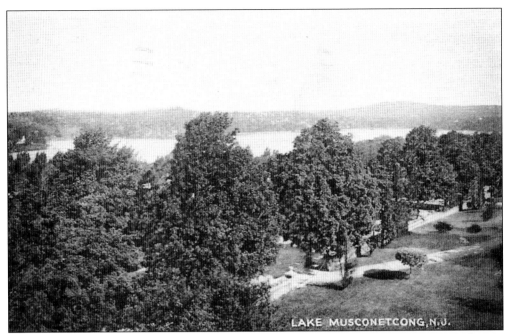

These views of Lake Musconetcong from the earlier part of the 20th century illustrate the beauty and tranquility of the lake. The Lake Musconetcong Regional Planning Board includes volunteers from Byram, Netcong, Roxbury, and Stanhope, as well as officials from both Sussex and Morris Counties and the state. Lake Musconetcong is 329 acres, with depths ranging between five and ten feet. The total watershed area for the lake is 14,000 acres. A 2003 survey of the types of fish in the lake includes the following: black bullhead, yellow bullhead, American eel, white sucker, common carp, chain pickerel, banded killfish, bluegill, largemouth bass, white perch, golden shiner, yellow perch, black crappie, chub, and walleye. (Both, courtesy of George Graham.)

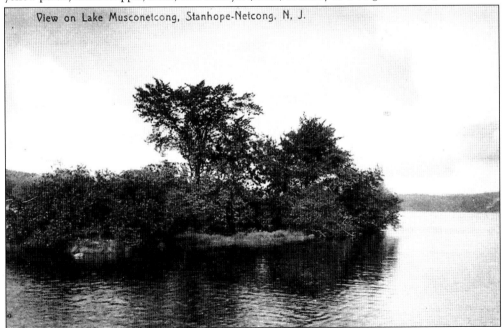

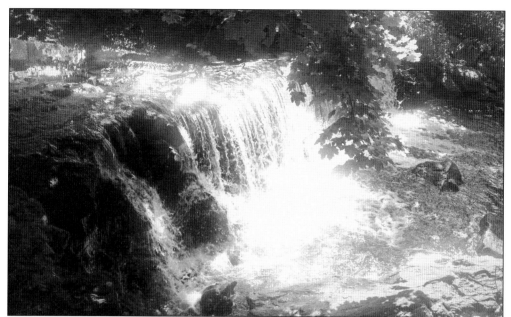

The above photograph shows the Musconetcong River roaring by and down the falls, where it joins with Furnace Pond. The river creates a divide between the Church in the Glen and the area by the former Morris Canal basin. There is now a small park, Salmon Park, in the area. The iron furnaces overlooked Furnace Pond, seen today in the below photograph, which is now a preserved area and home to flora and fauna. The area is protected through New Jersey's Green Acres program. Furnace Pond was another man-made water body, created to accommodate the local iron-production industry with waters dammed from the Musconetcong River. The water from the pond helped to provide energy to the plant's waterwheel. (Both, author's collection.)

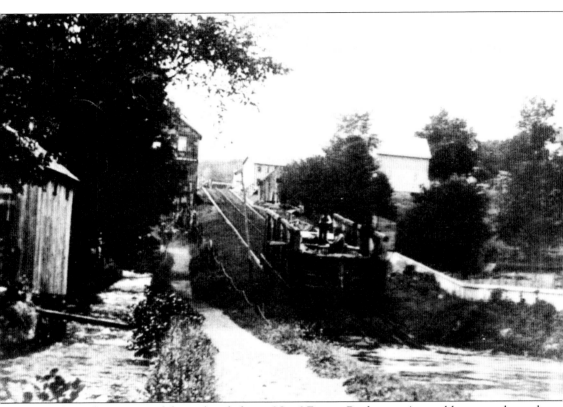

Shown here is one of the inclined planes, No. 6 East in Rockaway. A canal boat travels on the hill in the incline plane apparatus to its next leg of the voyage. This segment of the Morris Canal was 512 feet above sea level. The "summit," at 914 feet, was located at Port Morris (today's Landing area). Rockaway was approximately the halfway mark between the Western Terminus in Phillipsburg New Jersey, along the Delaware River and near the Pennsylvania border, and the canal's end at Jersey City, near the Hudson River. The entire stretch exceeded 102 miles, with Rockaway at around mile 52. Rockaway is situated about 10 miles east of Stanhope. There was also a lock in the Rockaway Valley area, today classified as Denville, known as Lock 8E. As they are today, these municipalities were more metropolitan than the areas along the farther western sections of the canal. (Author's collection.)

Two

EXPLORING STANHOPE BOROUGH

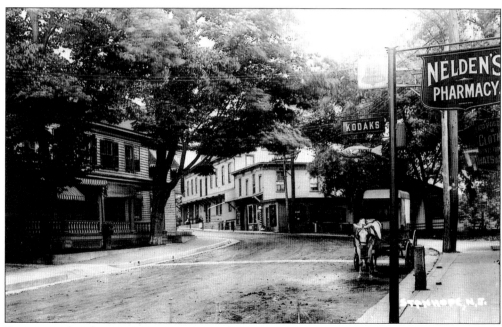

Downtown Stanhope's Main Street is seen here at the turn of the 20th century. Though today's roads are paved, and motors move four wheels, some beloved standbys, like the Stanhope House (left) are still here. Nelden's Pharmacy (right) opened for business in 1897; its proprietor, Dr. Harry Nelden, was Stanhope's first mayor. Nelden's, described as a "first class pharmacy," sold a range of goods, including real-photo postcards. (Courtesy of Ros Bruno.)

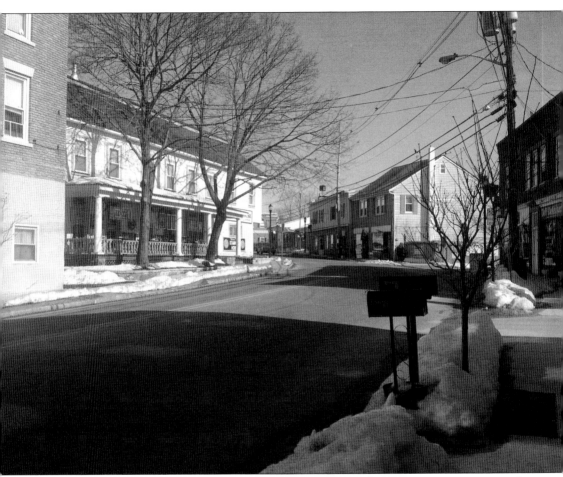

This photograph of Main Street and the Stanhope House was taken from a vantage point similar to that of the image on the previous page. The two trees at left, seen also in the previous photograph, are still standing today. Nelden's Pharmacy is long gone; Dr. Nelden sold the pharmacy in 1919. He and his father, Charles, held special places in Stanhope history. They were doctors together, beginning their joint practice in town in 1891. Charles ran a pharmacy within the practice prior to his death in 1897. (Harry died in 1932.) Charles and Harry Nelden were notable enough to have their deaths chronicled in the *New York Times*, and Charles's obituary also appeared in the *Journal of the American Medical Association*. Both men graduated from Bellevue Medical College. Charles served on Byram's board of education, and Harry was president of Citizens National Bank. In 1918, Harry, along with several residents of both Stanhope and Netcong, was an investor in the Kingden Realty Company of Morristown. (Author's collection.)

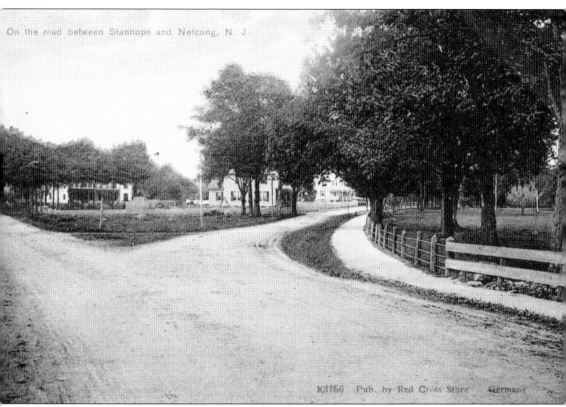

On the road between Stanhope and Netcong, N. J.

K3156 Pub. by Red Cross Store Germany

This undated postcard offers a view of the forked road at the border of Stanhope and Netcong. "Gess [sic] who," the sender poses to the recipient, a Wharton resident named Jan Trengenga, who received the card from an anonymous sender in Netcong, 10 miles away. The postcard was sent after 1903, the year when the particular postage stamp on it was first issued. Today, the roadway still veers to the right, heading into downtown Netcong. Not visible and off to the right is the property where the Church on the Glen is now located. To the left, also not visible, is where Lake Musconetcong is today. On parade days, such as Memorial Day, spectators will watch from along the tree-lined area and sidewalk. The left side of the road is now Route 183, formerly Route 31. Today, both roads are paved with asphalt. While some buildings remain, others have long departed. The nostalgia of this strip, though, still lives on. (Courtesy of Wayne McCabe.)

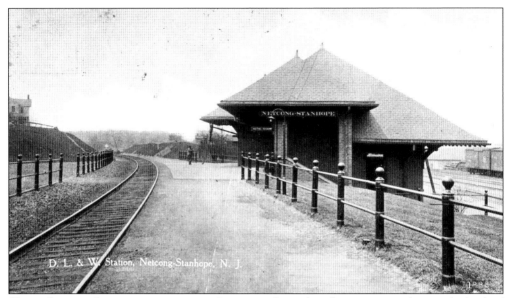

"Some day soon I expect to meet you at this station," one friend writes to another on the back of this postcard in 1913 about the Netcong-Stanhope station, shown above at that time. The station is shown below at a later date, in a photograph by William B. Barry Jr. Today, it is referred to as Netcong and is in the same building. In 1901, the Delaware, Lackawanna & Western (DL&W) rail line constructed the track and station, hauling in bricks from Port Murray, another stop along the Morris Canal. Service continued until 1966 for the Sussex Branch of the train line. Between 1979 and 1994, the station stood dormant. Service was reinstated, and the Netcong Station became a part of New Jersey Transit. The Montclair-Boonton line will eventually join with the old Lackawanna Cut-Off, from the former DL&W line. (Above, courtesy of Wayne McCabe; below, courtesy of Steamtown NHS Archives.)

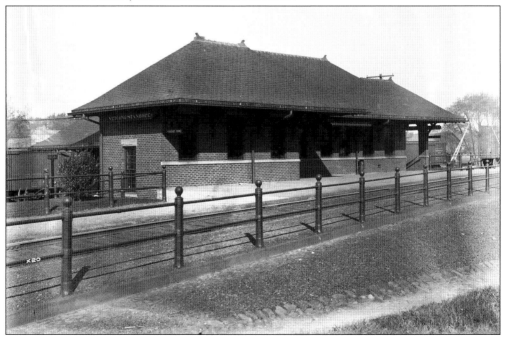

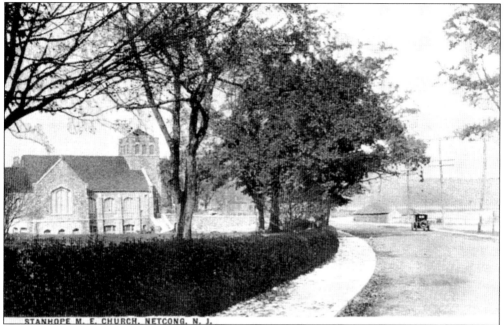

STANHOPE M. E. CHURCH, NETCONG, N. J.

The "Church in the Glen" stands across from Lake Musconetcong. The above postcard shows the church when it was still referred to as the Stanhope Methodist Episcopal ("M.E.") Church. It had previously been on Linden Avenue, across from Church Street in downtown Stanhope, from 1844 to 1920. The Sussex Iron Company donated the land to parishioners. The original structure was demolished upon relocation to the new sanctuary across from Lake Musconetcong. The new church was built with stone from Waterloo, with construction beginning in 1917 and completed in 1920. The Morris Canal was not yet officially abandoned and the dam not yet built. At the time of the below postcard, the dam was fully completed. (Above, courtesy of George Graham; below, courtesy of Wayne McCabe.)

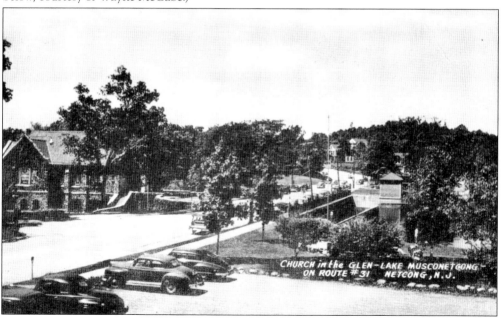

CHURCH in the GLEN – LAKE MUSCONETCONG – ON ROUTE #31 NETCONG, N.J.

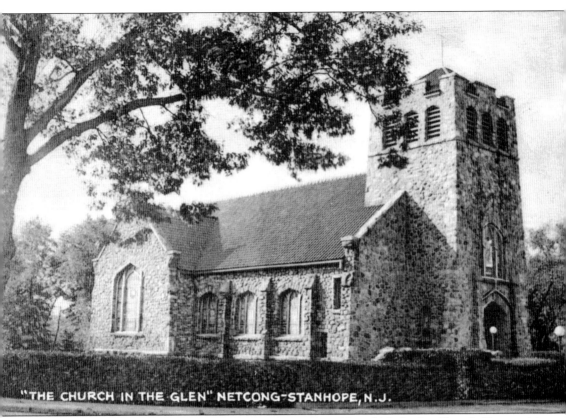

"THE CHURCH IN THE GLEN" NETCONG-STANHOPE, N.J.

Today, the "Church in the Glen" is known as Stanhope United Methodist Church. Designed in the Late Gothic Revival style, the church is in both the New Jersey and the National Registers of Historic Places. The church has undergone a historic renovation, including roof repair. It received several grants, totaling approximately $175,000, for its preservation plan, to repair a stained-glass window, for the cost of construction documents, and to repair the main and bell tower roofs. The church today resembles its original construction, outside of the historic repairs, although the education building was added in 1965. This postcard, showing the church in 1945, was sent to a recipient in Illinois from Eva Montonya, a Netcong resident. Another card from Montonya is featured in this chapter, from another postcard collection. (Courtesy of Ros Bruno.)

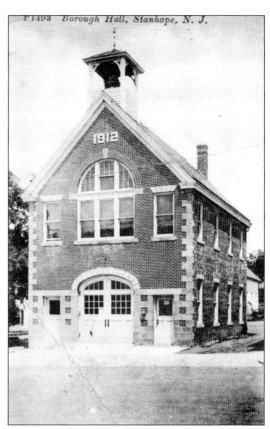

P1493 Borough Hall, Stanhope, N. J.

In 1912, about eight years after Stanhope officially became a borough, its first borough hall was constructed (right). The borough's first mayor, from 1904 to 1907, was Dr. Harry Nelden, who also owned the municipality's first pharmacy. Nelden's Pharmacy printed the card at right, which the sender mailed in 1918, proudly writing to the recipient that this was their "city hall" and that they were going to the lake that day "in a machine" (the old-fashioned word for an automobile or bicycle). Today, Stanhope Borough Hall (below) is located at 77 Main Street and is home to the municipal offices and police department. Constructed in the 1960s, it was recently remodeled, courtesy of an energy audit and grants awarded to improve the building's energy efficiency. (Right, courtesy of Wayne McCabe; below, author's collection.)

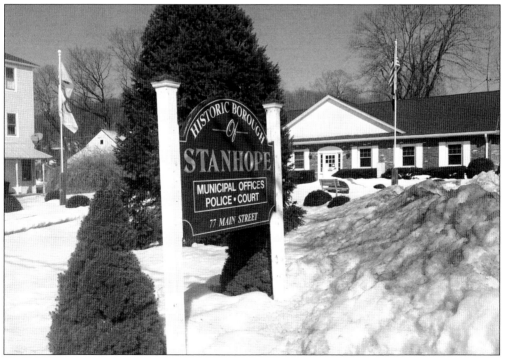

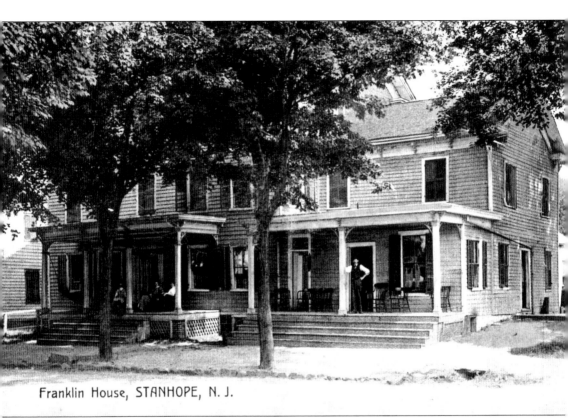

Franklin House, STANHOPE, N. J.

The Franklin House Hotel, then known as the Franklin House, was a spacious, multistory hotel on the property now occupied by the current municipal building. The house was razed in the 1960s to make way for Stanhope Borough Hall. This postcard, printed by Nelden's Pharmacy, depicts the Franklin House in its heyday. The card was mailed in 1909, and the sender urges the recipient to "Run up and see me." The recipient was a person in Rockaway, a municipality less than 15 miles away from Stanhope. When the structure was demolished, it was more than 120 years old. It started its life as a hotel and stagecoach stop. The Case family, then the Kelly family, were its proprietors. When Christopher Kelly owned it in 1913, it cost $2 a day to rent a room, equal to about $47 today. (Courtesy of Wayne McCabe.)

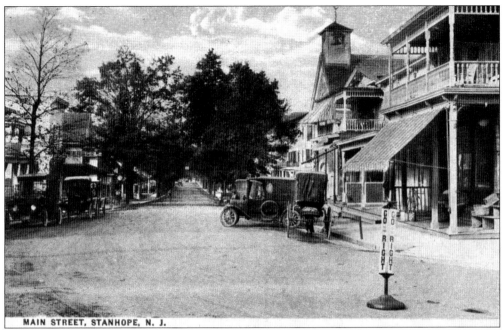

MAIN STREET, STANHOPE, N. J.

This is an early-20th-century view of Stanhope's Main Street, as automobiles were hitting the road but before traffic signals were prevalent. Times were still simpler, as evidenced by the correspondence (below) sent from a Hackettstown resident to someone in New York State. The sender advises the recipient of his mother's death. Gowanda, New York, is located near Buffalo. No George Hubert has been found in census records or other records for the Hackettstown area. A Jessie M. Robb, on the other hand, was located in a 1910 census search for Eden, New York, about 15 miles from Gowanda. Likely the recipient, Robb, was 17 years old at the time of the census. (Both, courtesy of Wayne McCabe.)

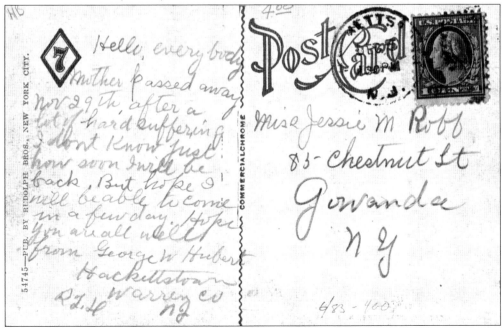

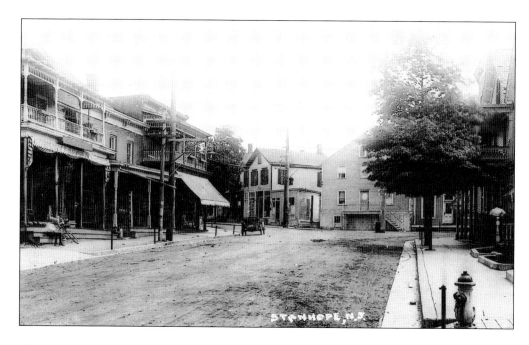

These two photographs of Stanhope's Main Street business section, taken years apart, appear to be from a similar vantage point. The above photograph was taken in the days still dominated by the horse-drawn buggy, based on the ruts and debris on the dirt road. A fire hydrant appears in the lower right corner of both images. The awning of the building in the below photograph is retracted in the earlier image. Nelden's Pharmacy, on the right in both photographs, is once again a focal point, as is its sign indicating long-distance telephone service. Toiletries, candies, and stationery were available at the store, in addition to medicines and postcards. (Above, courtesy of Ros Bruno; below, courtesy of Wayne McCabe.)

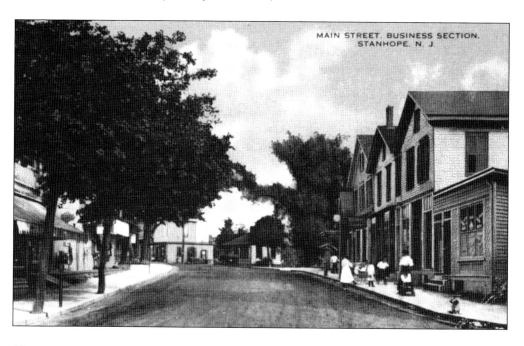

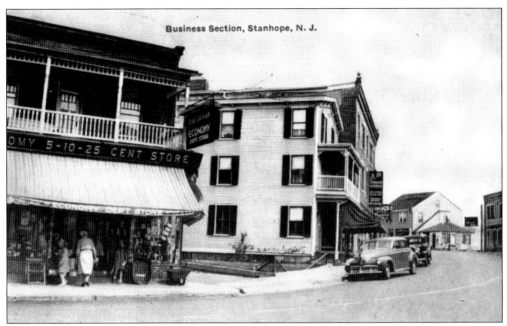

Business Section, Stanhope, N. J.

Included in this view of downtown Stanhope is one of its popular stores at the time, the Economy Department Store. Members of the Schwartz family, including Hyman, Sol, Mae, and Naomi, were among its owners, and locals still fondly remember this institution, especially its toy department. Eva Montonya mailed this card in 1945 to a pen pal in Pennsylvania, indicating that the store is accessible to her home from across the bridge in Netcong. Montonya is recorded in the 1910, 1920, and 1930 censuses. Her husband, Jerry, was an engineer on the railroad. They had three sons, Vernard, Willis, and Harrell. In those days, pen pals often met through magazine advertisements. Eva obviously was very engaged with her pen pals, as two of her cards from two separate collections are featured in this book. (Both, courtesy of Wayne McCabe.)

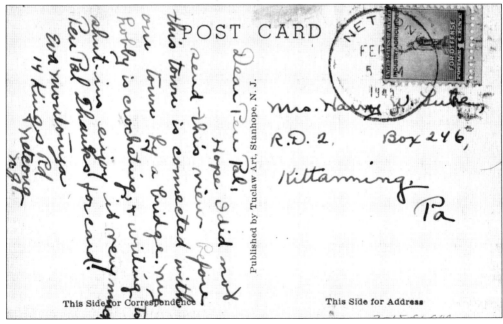

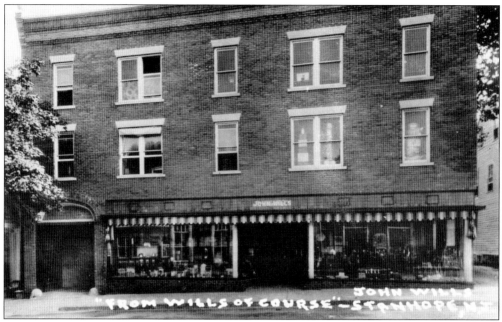

The John Wills Building is seen in a vintage photograph (above) and in a current photograph (below). John Wills was a prominent Stanhope citizen and the borough's mayor in 1913. His store, known as a "dealer in lumber, coal and building material," was referred to in the 1920s as "A City Store in the Country." Wills was born in Stanhope and was a Rutgers alumnus. The Wills family itself has a long-standing history in Stanhope Borough, with family found on Linden Avenue in census records. Today, Wills Avenue is one of Stanhope's streets. The building, located between the Stanhope House and Stanhope Borough Hall, is now an apartment building (below). The arched doorway on the left is recognizable in both photographs. (Above, courtesy of Wayne McCabe; below, author's collection.)

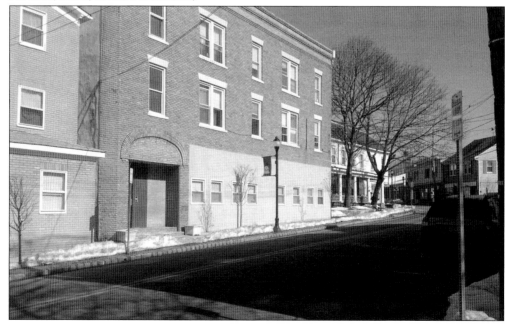

Main Street meets Kelly Place in this photograph. The municipal building is on the right. The building with the balcony in the foreground on the left is 66 Main Street. This was the site of Otto Almer's business. He was trained in two professions, as a carpenter and as an undertaker. Though born in New York City, Almer's heritage was Danish, and he learned both trades from his father. He is listed as early as the 1880 census, as an undertaker, when Stanhope was still noted as a village. Other prominent citizens, including both Drs. Nelden, appear at the top of the same census report page. Otto Almer's wife, Matilda, and their son Amos, then age 18, are also listed. In the 1870 census, Otto's occupation is listed as "carpenter," when he resided in Warren County's Independence. He died in 1914 and is buried in the Stanhope Union Cemetery in Netcong, in the same plot with Matilda, Amos, and Amos's wife, M. Elizabeth. She is listed in the 1910 census in Byram along with their three daughters; Amos is also listed, as an undertaker. (Author's collection.)

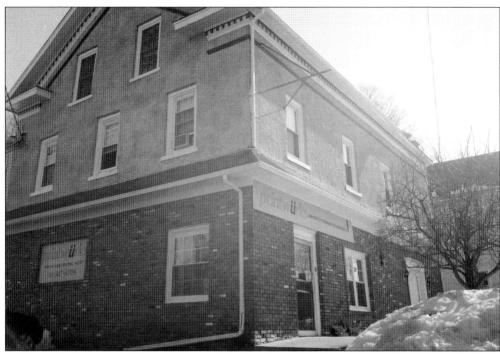

This page features two prominent and longtime buildings on Kelly Place (in the days of the canal, known as Bridge Street). Shown above is 6 Kelly Place; across the street is 1–3 Kelly Place (below). Printwürks and JWS Financial are housed at 6 Kelly Place, a building owned by resident John Spooner. This was formerly Hulse's General Store, opened around 1850 and owned by John Hulse and his family, who were proprietors of another store in Kenvil; both were popular storefronts along the canal. The Stanhope Bottling Works across the street was a flourishing business in town, run by Peter Kelly. His father, Christopher, was a prominent resident involved in the iron business before starting a bottling business, specializing in beers, ales, wines, liquors, and sodas. He then owned both the Franklin House, which his son John managed, and the Rockaway House in Morris County. (Both, author's collection.)

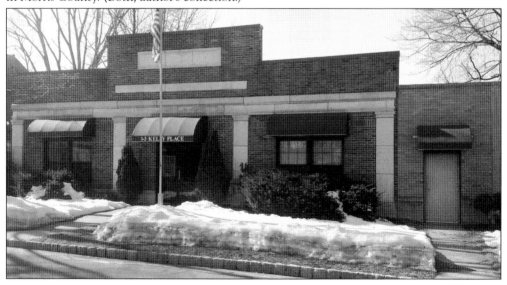

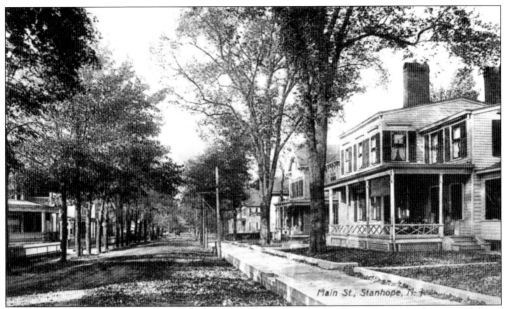

These two photographs of a stretch of Stanhope's Main Street span many years, from the days of the horse and buggy and dirt-covered streets to today's age of asphalt and automobiles. Nevertheless, some details are quite similar. The white home on the right in both photographs was built in 1900. Today, this building at 83 Main Street is home to Hartnett Art Studio. The original shutters and chimney still appear intact. The home next door to it, 85 Main Street, was constructed in 1875 and still retains much of its original look. The home with the balcony on the left, at 81 Main Street, was owned by Edwin Post around 1840. He was a New York capitalist, instrumental in starting the Sussex Iron Company. The early homes in this area bordered on the Stanhope Village Green, which was in existence until about 1870. (Above, courtesy of Wayne McCabe; below, author's collection.)

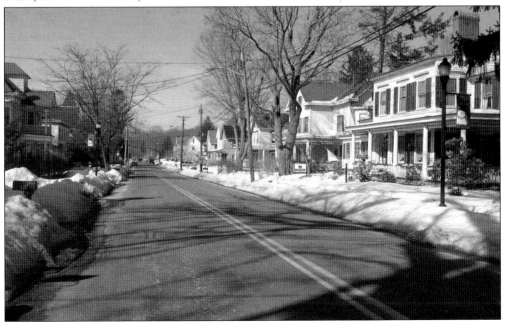

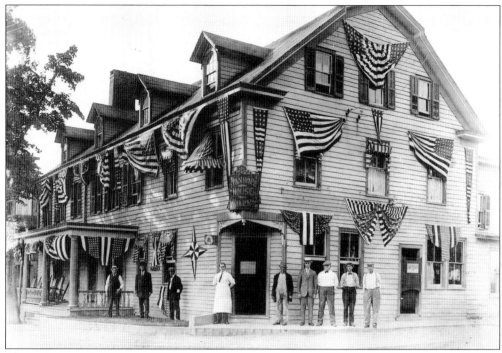

These photographs of the legendary Stanhope House were taken when it was under the ownership of proprietor Frank P. Kisz. It has had an interesting and colorful history, and quite a few characters have passed through its doors since its construction around 1794. Over the years, the Stanhope House (also known as the Stanhope Hotel during Frank Kisz's ownership) has been a home, stagecoach stop, post office (under Gamaliel Bartlett), hotel, general store, rooming house (including rumors that it was a brothel), and blues club, now known as the Last Great American Roadhouse. A 1913 review of the Stanhope House states, "Modern in every detail, the best to eat and drink, tourists and automobile parties." (Above, courtesy of Ros Bruno; below, Wayne McCabe.)

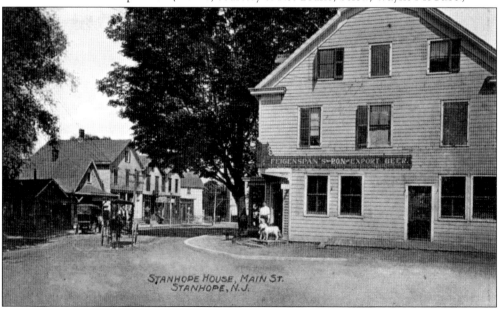

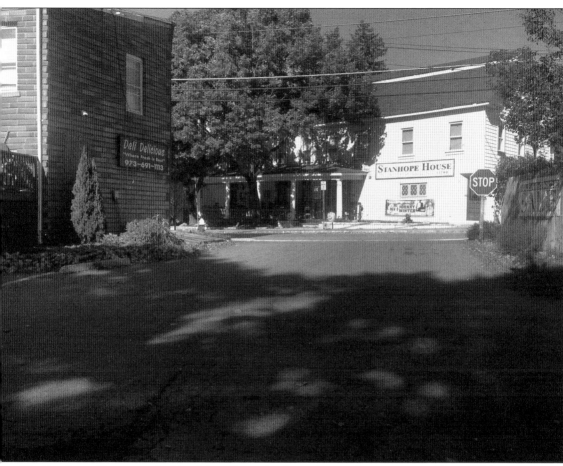

The Stanhope House, overlooking Main Street, has hosted many famous patrons. Daniel Webster spoke from a building across the street and diagonal from the house, at what is now the Kelly Place parking lot. Other visitors have included Babe Ruth, Stevie Ray Vaughan, Muddy Waters, and John Lee Hooker. Frank Kisz's sign hangs over the club's 18th-century mantle, where the past meets the present. During the days of the canal, it was a popular stop along the route. While the club was under the ownership of the Wrobleski family in the 1970s, it was not uncommon for Stevie Ray Vaughan to help with dishes and for other performers to sit with the family for Thanksgiving dinner. The Deli Delicious building (left) is made of hollow terra-cotta tiles. These tiles may have been manufactured in Byram Township around 1915 as a project with experimental materials. The tiles are similar to some found in an abandoned home near Waterloo Village. The parking lot behind the Deli Delicious building is where the canal once flowed. (Author's collection.)

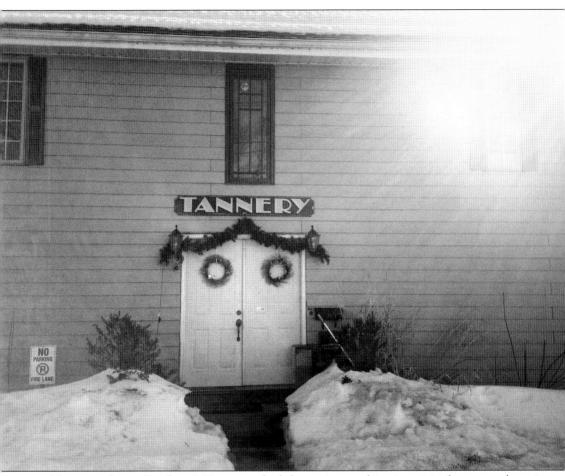

Now a residence, Stanhope's Tannery, which has a sign marking its original purpose above its front door, was built in 1860. The building sits to the left of the borough's firehouse. There was another tannery prior to this structure, but it burned to the ground. Resident Cornelius Cottrell owned the tannery and other land in town, at 110 Main Street, where the Whistling Swan Inn is now located. The tannery was one of the stops along the canal, as were other utilitarian structures, such as two gristmills, depots, general stores, the sawmills in town, and the plaster mill. In addition to these industrial buildings, some, now gone, were used for leisure purposes around the same section of town, including two classified as opera houses. One of them, Woolston's in Stanhope, hosted minstrel shows and silent movies. (Author's collection.)

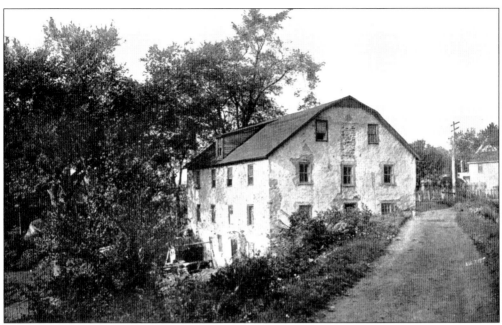

Now guarded by a fence with signs indicating that it is a part of New Jersey's Green Acres program (below), what is left of the Stanhope Plaster Mill is now in ruins. But it is not held in any less esteem in the hearts of locals. The plaster mill (above), about 300 feet from the intersection of Main Street and Kelly Place, has been in the National Register of Historic Places since the late 1970s. Originally constructed in the early 1800s, it was first documented in 1828 on the Morris Canal & Banking Company map. Its original usage was as a facility for grinding gypsum for farming. At the end of the 19th century, the property served as housing for immigrant Irish laborers who worked at the iron forges. (Above, courtesy of Wayne McCabe; below, author's collection.)

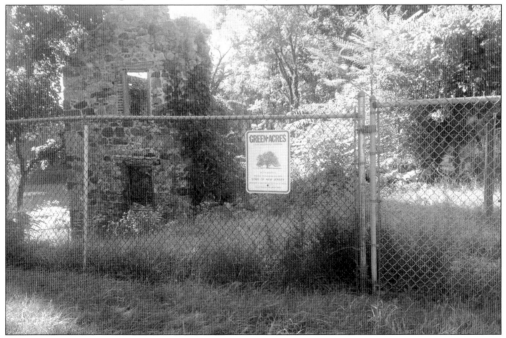

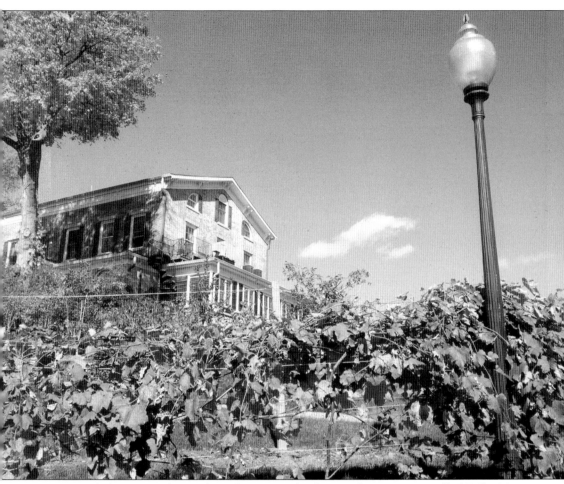

Previously known as the "Red Brick House," this historic home is now called Bell's Mansion, named in tribute of its first owner, Robert P. Bell. President of the Morris Canal and Banking Company, he sought a view of the canal, mills, and ironworks operations. He brought the dream to fruition around 1835 through the construction of his home, from which he could observe the various operations. He did so in comfort and style; the beautiful brick structure was accented by detailed features. Following Bell's ownership, Andrew Smalley, who owned a store and canal depot in town, lived there. Abraham Clark used the home as a boardinghouse. In 1905, Herbert K. Salmon, who owned Salmon Brothers Construction Company, the group that built the state's first concrete highway, moved into the home with his family. The Salmon family retained a presence there until 1977. The home then lay dormant until 2006, when it gained a second life as a renowned area restaurant. (Author's collection.)

The home at 90 Main Street (above) was the original site of the Stanhope Public School system, which educated the children of the town during the height of the Morris Canal operations, from 1850 through 1890. "Old Friend, Guess" is penned on the back of the postcard shown below, sent anonymously from Stanhope in 1907. The large public school was built off of Linden Avenue and began serving students in town in 1890. The stately brick building had three stories and served both the girls and the boys of the town. There is a brick school on the street today, only one level, with parklike grounds similar to the original school. It is used as a prekindergarten institution. Students today begin their educations in Stanhope at Valley Road Elementary School, then can proceed to Lenape Valley Regional High School. (Above, author's collection; below, courtesy of Wayne McCabe.)

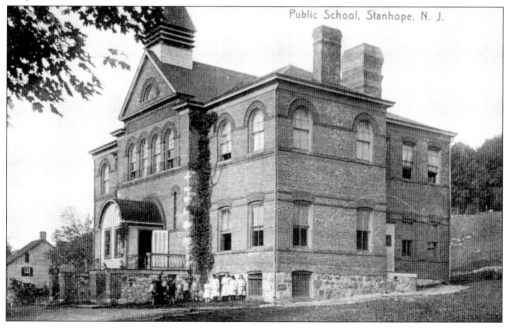

Public School, Stanhope, N. J.

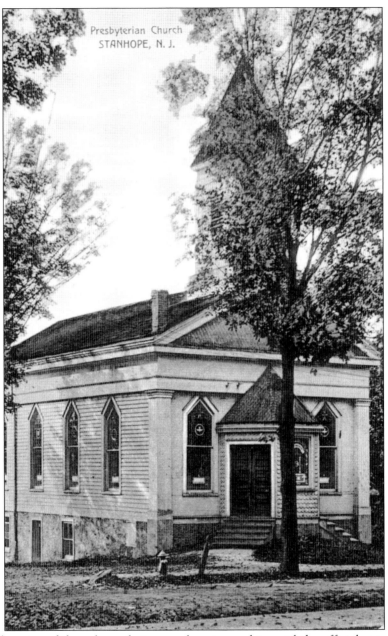

Local Presbyterians did not have their own place to worship until the official organization of the Stanhope Presbyterian Church on June 11, 1838. In 1843, Rev. Nathaniel Elmer became the church's first minister. The structure, next door to Stanhope's first school on Main Street, was completed in 1844 with land donated by the iron company. The church overlooked the Stanhope Village Green, which is now a memory. The church and the annex that served over its lifetime as housing for ironworkers have remained similar to the original, but there have been several expansions. Today, it is known as the First Presbyterian Church of Stanhope. In 2013, it celebrated 175 years of service to the community. Just as the Presbyterians gathered for the first time in 1838, today's congregation met on June 2, 2013, for a service, then enjoyed a celebration lunch to mark the milestone of the church's life in the community. (Courtesy of Wayne McCabe.)

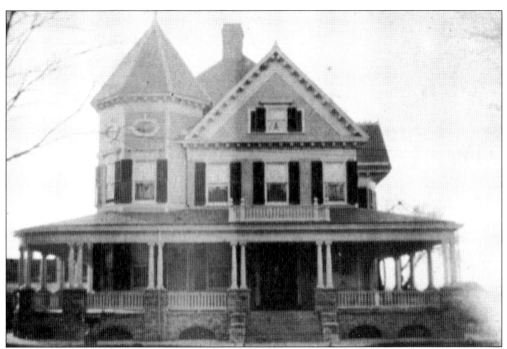

Daniel Best sought the ultimate gift for his love, Sarah. What better gift could the borough's justice of the peace give than a new residence? Cornelius Cottrell, proprietor of the tannery, owned a small house and land at 110 Main Street, which he sold to Daniel, who subdivided the land and gave the home to his brother, William. On his own strip of land, Daniel built a spacious mansion that his family remained in until 1941. The Salmons, the same family that lived in the Bell mansion, resided at 110 Main Street until 1966. Other families lived in the home; after it was unoccupied for several years, it was transformed into a bed-and-breakfast in 1985. Now, two innkeepers later, Ros and Tom Bruno oversee the home, called the Whistling Swan Inn. (Above, courtesy of Ros Bruno; below, author's collection.)

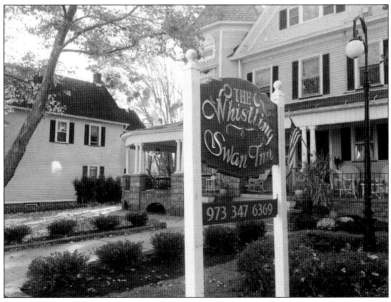

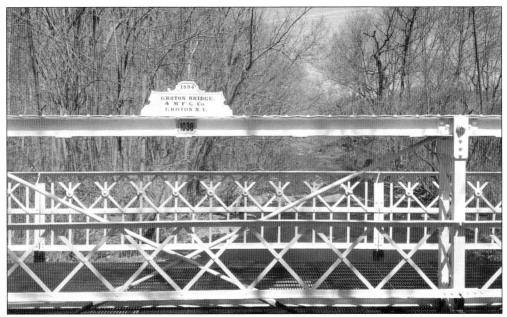

Seen here in modern-day photographs, the lovely Waterloo Bridge was erected in 1894. It is located on Waterloo Road, which eventually leads to the Stanhope Union Cemetery. The bridge, which passes over the Musconetcong River, has been the subject of concern in recent years, as the structure has required repair. Yet there has been a desire to keep the look of the original span, which has an open grate and ornate details. The borough has sought funding for the repair, but approval has come only for the bridge's replacement. The council has discussed regulating the size and speed of vehicles allowed to use the bridge, and it has considered utilizing the existing steel trusses and sidewalk for a replacement bridge, in order to maintain its original character. (Both, author's collection.)

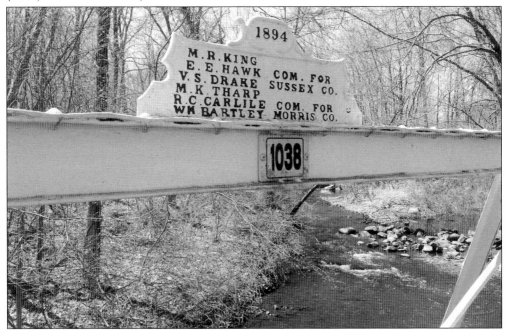

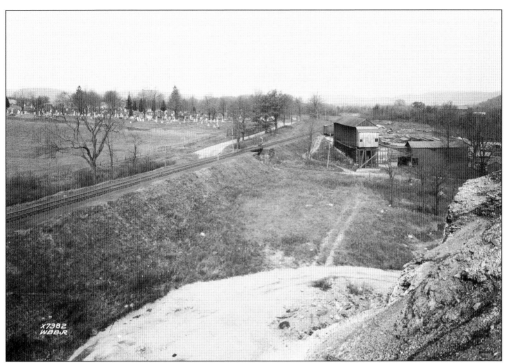

Shown here are past and present views of the intersection of Waterloo Road and the Stanhope Union Cemetery. The above photograph, dated around 1930, was taken by William B. Barry Jr. It shows where the Sussex Branch of the railroad passed through Stanhope, in front of the cemetery. The coal trestle, which passed under where today's intersection now exists, was said to have belonged to John Wills, the town's lumber dealer. The below photograph shows the original abutment from that trestle, still in existence, though overgrown and slightly dilapidated. (Above, courtesy of Steamtown NHS Archives; below, author's collection.)

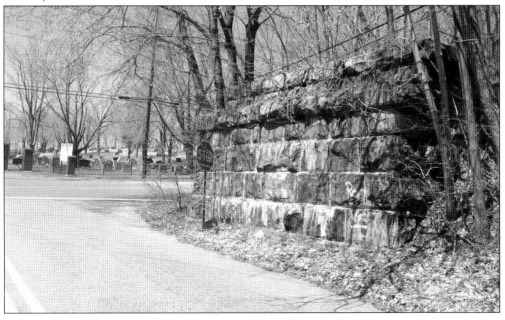

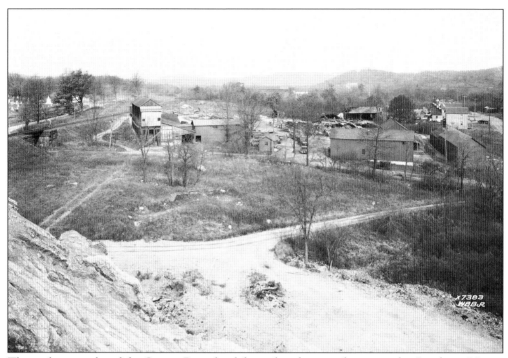

These photographs of the Sussex Branch of the railroad were taken near the Stanhope Union Cemetery by William B. Barry Jr. Visible in the above photograph are buildings believed to have been part of the Sintering Machinery Corporation. A structure in the distance appears to be collapsed. The below photograph was taken from the area of the coal trestle, which is off to the right, near the boxcar. The New Jersey Arnold Damper Company, which manufactured mining machinery, is visible in the distance at right in the photograph above. It was eventually acquired by Sintering, a company headquartered in New York City. (Both, courtesy of Steamtown NHS Archives.)

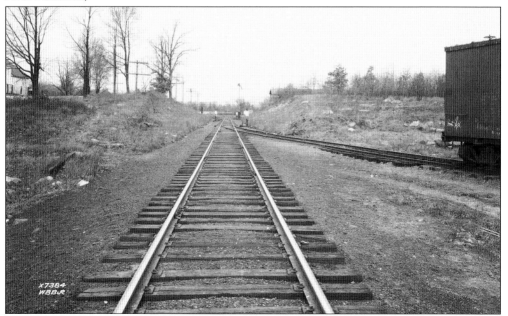

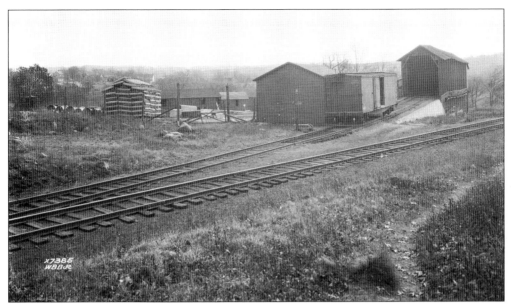

These photographs from the Steamtown NHS archives were taken by William B. Barry Jr. around 1930. The Stanhope Union Cemetery would have been behind the photographer, who was facing toward the direction of what is today Waterloo Road. To the far right in the above photograph is the coal trestle and John Wills's lumberyard. In the distance, the Borough of Stanhope is visible. The below photograph offers a closer view of the lumber stacked in John Wills's yard, ready to be transported to its final destination. (Both, courtesy of Steamtown NHS Archives.)

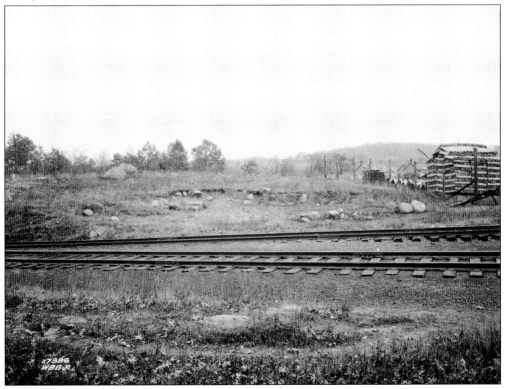

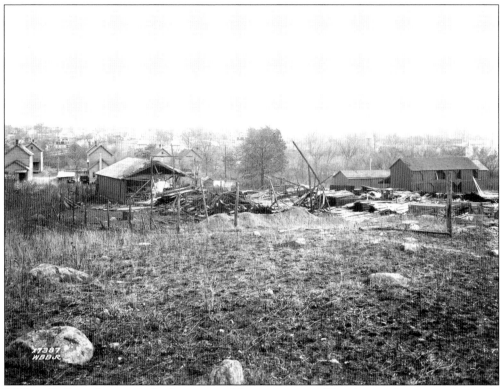

William B. Barry Jr. captured other views of this same area of Stanhope, adjacent to the tracks of the Sussex Branch of the Delaware, Lackawanna & Western Railroad. In the left distance in the above photograph are Stanhope residences and an old car, dating the image to around 1930. The structure left of center may have suffered from a fire or simply been severely dilapidated. The below photograph shows John Wills's facility, which specialized in various types of building materials. Early-model automobiles are visible behind the supplies, and an old wagon is on the left. (Both, courtesy of Steamtown NHS Archives.)

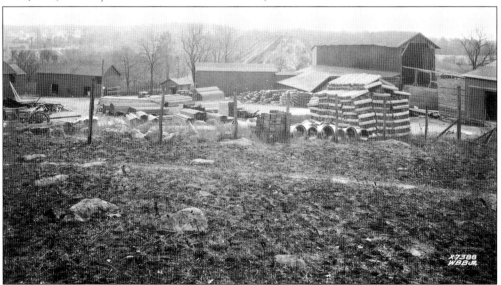

Three

CRANBERRY LAKE MEMORIES

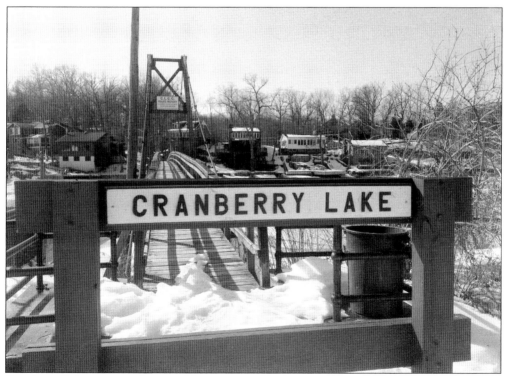

Cranberry Lake is currently one of the year-round bedroom communities for residents in Byram Township. The community's history includes its service as a feeding source for the Morris Canal. It is a popular tourist destination, with its own colorful and unique history in the early part of the 20th century. (Author's collection.)

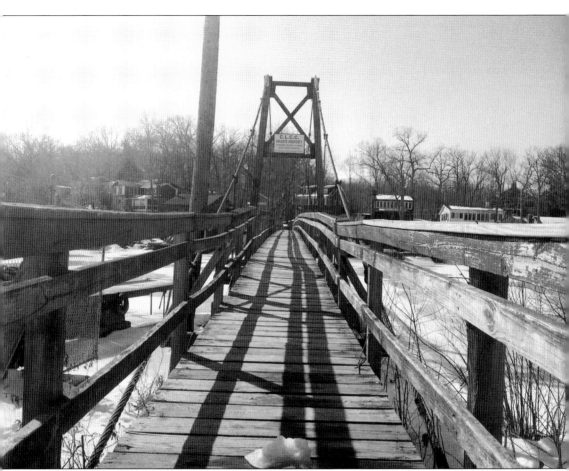

The Cranberry Lake Bridge is seen here in a current photograph. This is the third of three bridges during the lake's lifetime. The first, built at the turn of the 20th century, permitted early visitors the opportunity to venture onto the island directly from the railroad station. However, the crowds visiting Cranberry Lake soon turned rowdy, and debauchery at the local hotel constructed to accommodate the influx of visitors became commonplace, to the dismay of the lake's residents. The city slickers who visited the lake area interrupted the tranquility of the peaceful community. In 1910, the footbridge was dismantled; the following year, the hotel burned down. A footbridge existed in the 1920s for a few years; in 1929, the bridge that remains today was built as its replacement. (Author's collection.)

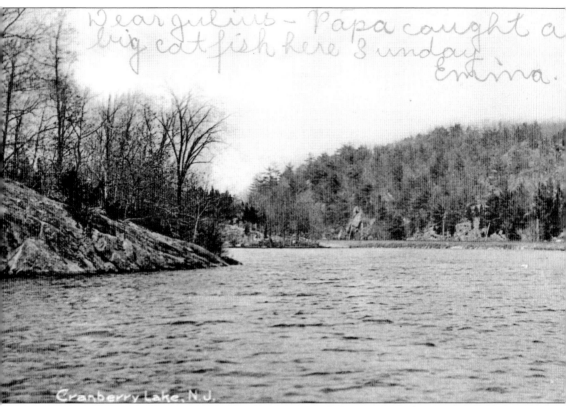

Dear Julius – Papa caught a big catfish here Sunday. Emma.

Cranberry Lake, N.J.

This vintage postcard of Cranberry Lake was actually mailed from Newark, New Jersey, to a recipient in New York State in 1906, during the lake's tourism heyday. "Dear Julius," the sender has scripted on front of the card in pencil, "Papa caught a big catfish here Sunday. Emma." During the years 1900–1910, every Sunday, the DL&W, formerly the Sussex Railroad, carted approximately 1,000 passengers to the Cranberry Lake station, which was built in 1898. For about 15¢, naphtha launches, which were small boats operated with steam motors, carted passengers around the lake for pleasure activities, including fishing. The sender of the card, Emma, likely visited the area for the day and picked up a souvenir postcard during her travels, then reported back the exciting adventure to her friend in Callicoon, a small town in Sullivan County, New York. (Author's collection.)

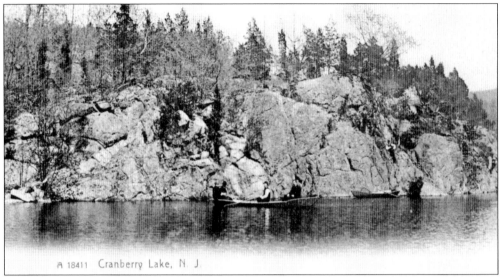

A 18411 Cranberry Lake, N. J.

Here are two more classic Cranberry Lake postcards from the turn of the 20th century. The above postcard depicts tourists in rowboats by one of the idyllic spots in the community. Shown below is a view of the hotel, often referred to as the Pavillion. Cranberry Lake was variously known as "Big Basin," "Cranberry Bog," and "Cranberry Reservoir" before it was dammed in 1830 to create another hydro source for the Morris Canal. Before that, it was farmland populated with red cedar trees. When tourism set in, visitors crossed the footbridge to the section that has become known as "Frenches Grove," where they could enjoy a small amusement park and recreation on rowboats or sailboats. (Both, author's collection.)

Andover, N. J. Cranberry Lake.

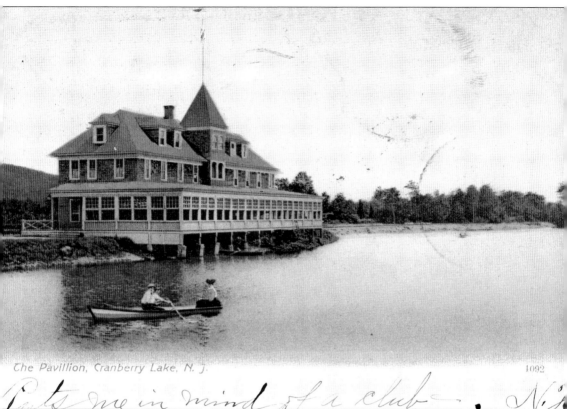

The Pavillion, Cranberry Lake, N. J. 1092

Puts me in mind of a club — . N. J.

The Pavillion at Cranberry Lake is featured on this postcard, mailed from Jersey City in 1907. The sender was likely one of the weekend visitors who took a jaunt by train to the vacation destination from the city. "Puts me in mind of a club," is what the sender has penned to a friend in Massachusetts. At the hotel, constructed in 1903, guests partook of liquor and enjoyed dancing and the casino. Fistfights often took place there between locals and out-of-towners. In 1911, officials declared the bridge "dangerous," hooked it up to a train one night, and pulled it into the water, putting a stop to the debauchery that terrorized the tranquil community. The hotel was engulfed in flames the same year, ending the era of wild tourism. (Author's collection).

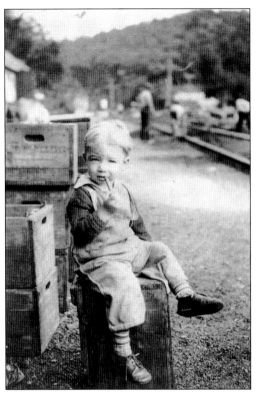

In the early 1920s, the Cranberry Lake Development Company was formed to create a family-oriented community within the scenic area. A clubhouse was built where the hotel had been, and that building served as Cranberry Lake's post office. The railroad remained, and the Cliff Inn was one of the venues along the track. The little boy in these photographs is Daniel Sutton, spending time along the tracks in front of his family's store in the 1920s. The Cliff Inn had become known as the "surrogate" train station during its day. Young Daniel Sutton, whose son now owns the treasured family images, was approximately three years old at the time these photographs were taken. At left, he poses in front of the store perched on a wooden carton; below, he stands with a toy gun. (Both, courtesy of Daniel Sutton.)

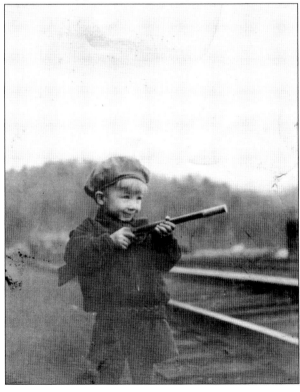

Henry Clifford Sutton, the owner of the Cliff Inn, sits in front of the store in the 1920s (right). The building later housed Sutton's Store and Bert and Mary's store. Friends knew Sutton as "Cliff" or "Cliffy." His grandson, Daniel Sutton, still has a chair from the Cliff Inn, similar to what his grandfather is sitting on in the photograph. Below, Alice (Kehoe) Sutton is brilliantly captured in a moment in time, as an unidentified man interrupts her activity of sweeping the front porch of the Cliff Inn, holding her broom hostage in an undated photograph. An August 1969 *New Jersey Herald* reports that Alice passed away at age 83 that year. She remained active in the community, retiring after Henry's passing in 1957. (Both, courtesy of Daniel Sutton.)

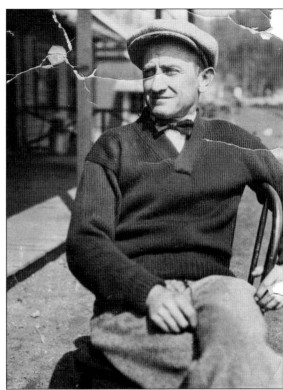

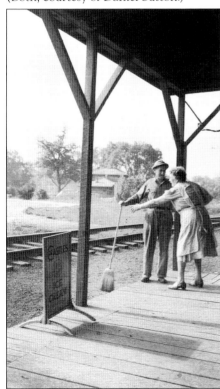

These two photographs of the Cliff Inn are now treasured items in Daniel Sutton's family archive. The above photograph is likely one of the earliest of the Cliff Inn, taken in the 1920s. Below, the inn stands adjacent to the railroad tracks. In addition to serving as the area's general store, the Cliff Inn was also the first known headquarters for the Lakeland Emergency Squad. Daniel's father, Daniel E. Sutton, was one of two teenagers (along with George B. Johnson) integral in starting the squad. World War II whisked many squad members away, with the group reorganizing in 1946. The group purchased a fire truck from Andover Borough and incorporated as Lakeland Volunteer Salvage Unit in 1947. It adopted its present name in 1954. The Cliff Inn remained headquarters until 1956. (Both, courtesy of Daniel Sutton.)

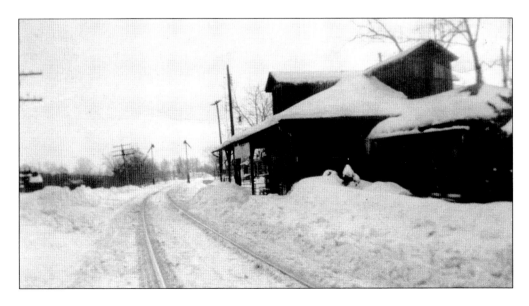

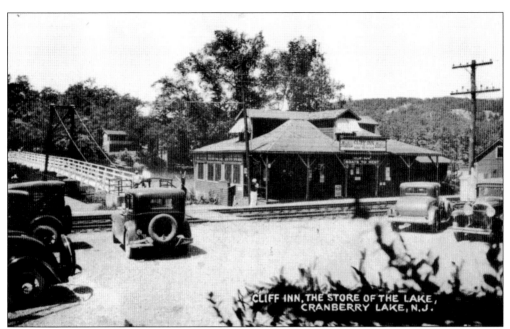

CLIFF INN, THE STORE OF THE LAKE,
CRANBERRY LAKE, N.J.

Above, the Cliff Inn is seen on a postcard sent in 1949. It stands to the right of the bridge, behind what was the Adam Todd Restaurant (now vacant). In those days, the inn boasted a soda fountain and boats to rent for fishing and leisure. The train tracks still ran alongside the inn and parallel to present-day Route 206 (known as Route 31 before New Jersey state highway renumbering took place in 1953). The postcard sender reports "wonderful weather but fishing is punk," a colloquial and antiquated adjective meaning "unsatisfactory." However, the visitor to the Cranberry Lake area notes that the weather was then "nice and cool to sleep." Obviously, Daniel Sutton (right) begs to differ regarding the "punk" fishing, based on the plentitude of his catch. (Above, courtesy of Wayne McCabe; right, courtesy of Daniel Sutton.)

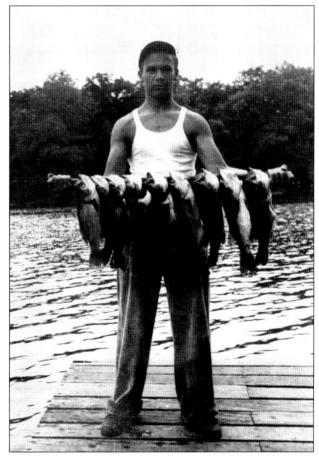

In these photographs, smiling Alice (above) and Cliff Sutton (below) pose by their store in 1952. The Cliff Inn is off to the right, not visible, in the above photograph. Below, only a corner of its roof can be seen. The below photograph was taken five years prior to Cliff's passing and Alice's retirement from the store. At this time, the Lakeland Volunteer Salvage Unit was still headquartered at the location, and the group by now had acquired its first ambulance and had diving equipment. The railroad tracks were still present, though the industry was in decline due to automobiles and trucks. (Both, courtesy of Daniel Sutton.)

Pink
Elephant
BAR — GRILL

PACKAGE GOODS
TO TAKE HOME

347-9827

60 FT. PICTURE
WINDOWS

ROUTE 206
CRANBERRY LAKE

This is a souvenir from the Pink Elephant, a bar and grill on Route 206 in the Cranberry Lake section of Byram. The venue, closed since about the 1980s, was located next to Bert and Mary's store. Those who remember the Pink Elephant recall its scent, which was the odor of beer (some remembering Rheingold) and, as the owner of this image, Bob Donlan, has said, wet wood. "It was very cool inside," he said. "The view was great." The bar was said to be at the same level as the lake itself and built on pilings. While some residents remember a view of the bar while playing pinball at Bert and Mary's, others recollect playing pool in the establishment and the ball drifting on the table, which was uneven because the Pink Elephant building was leaning in the direction of the lake. (Courtesy of Bob Donlan.)

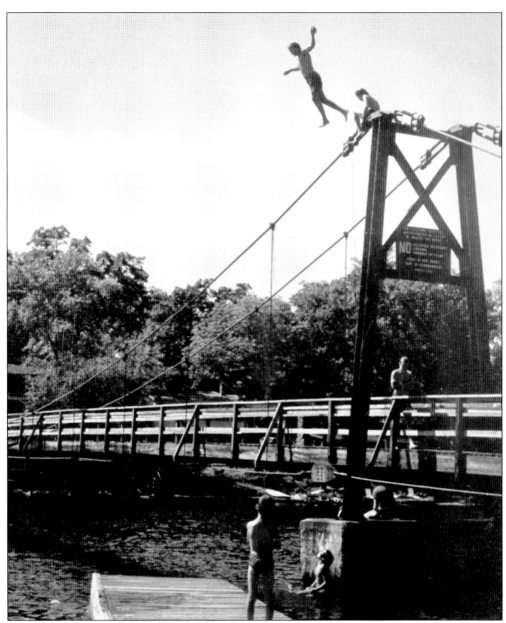

Brave local children cool off on a summer's afternoon by jumping from the top of the Cranberry Lake Bridge into the lake below, in spite of the sign forbidding diving off of the bridge. As one boy walks off the bridge into the water, another takes in the view as he leisurely sits on top of one of the bridge's towers. Bob Donlan photographed this occurrence in the mid-1980s. Today, the bridge's sign boasts that the overpass is Cranberry Lake Country Club private property and that swimming, diving, jumping, and fishing from the location are forbidden. The bridge itself is private and owned by the club as well. This bridge is one of three pedestrian suspension bridges accounted for in the state, with one built at approximately the same time on the Douglass Campus at Rutgers University, which connects to Cook College. The other bridge, in Sussex County, is known as the Pochuck Quagmire Bridge, along the Appalachian Trail in Vernon. (Courtesy of Bob Donlan.)

The two photographs on this page, taken in the 1980s, are familiar sites for those local to Byram who frequented Cranberry Lake. Shown at right is the "Tarzan Swing." Many residents have fond memories of the swing, which was later removed for safety reasons. The below photograph depicts the spillway, which dammed the lake area. Photographs exist of a spillway structure as early as the 1920s. Many "alumni" of Cranberry Lake youth remember time spent on the spillway, enjoying a few drinks. The original spillway from the 1920s made way for this structure, built in the 1960s. The tree for the Tarzan Swing was adjacent to the spillway. (Both, courtesy of Bob Donlan.)

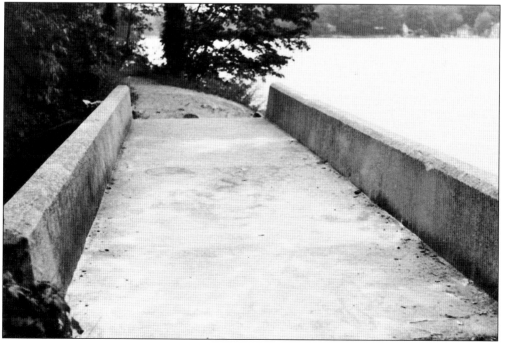

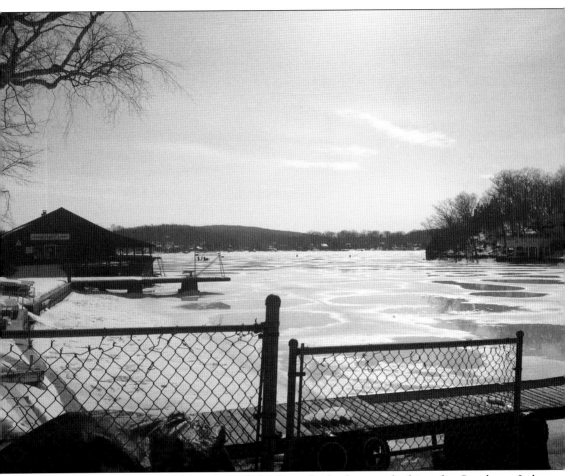

This is a current view of Cranberry Lake from the bridge, overlooking the Cranberry Lake Community Club House. On this day, locals enjoy weekend activities on the ice, though the waters are thawing. Pictured at left is Clubhouse Beach. The other beach along the lake is Rose's Beach, named after family. Oliver Rose was one of the lake community's first property owners in 1902. In the past, when the lake would be lowered, Rose's Beach was apparently a prime location to search for arrowheads, as many had been found along the shoreline. During the summer months, lifeguards are stationed at both beaches. The community offers swim lessons to the children in the community. There is also a swim team and a synchronized swimming program for the youth of Cranberry Lake. The synchronized swimmers perform each year in August on the second Sunday of the month. (Author's collection.)

Four

WATERLOO VILLAGE AND SURROUNDING AREAS

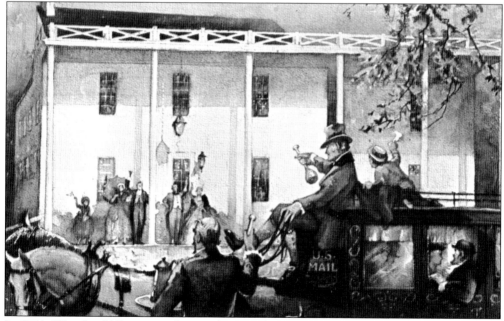

In 1964, Waterloo Village gained a new lease on life, as a local tourist attraction. In its earlier history, it was a colonial village, then a stop along the Morris Canal. This is an artist's rendering from a 1960s postcard of the stagecoach inn in colonial times. In 1831, when the canal was in full operation, the inn was transformed into a tavern and was a popular stop along the canal. (Author's collection.)

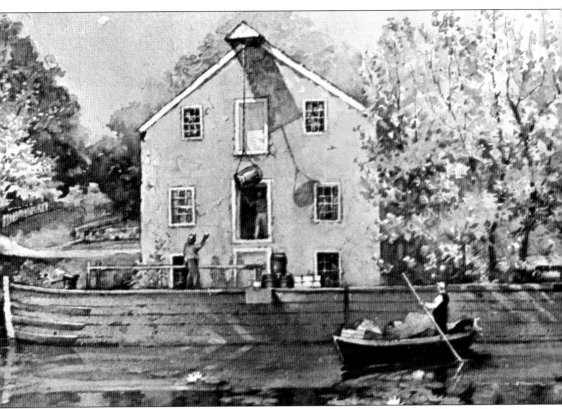

This 1960s postcard features an artist's depiction of canal operations. A canal boat unloads goods at the village's country general store. Canal boats simply pulled up to the rear of buildings, where items were lowered from the store; or, conversely, items were brought up from the boat, into the store, during drop-offs. From this location, boats proceeded to Guard Lock No. 3 West, then continued on their journeys. Today, that portion of the canal is still in existence. A blacksmith shop was next to the lock, and Inclined Plane No. 4 was also in the area. Percival Leach and Louis Gualandi were instrumental in spearheading the initial revival of the village, which became a part of Allamuchy Mountain State Park. Smith's Store, as it is now known, was built in 1831 and sold dry goods. (Author's collection.)

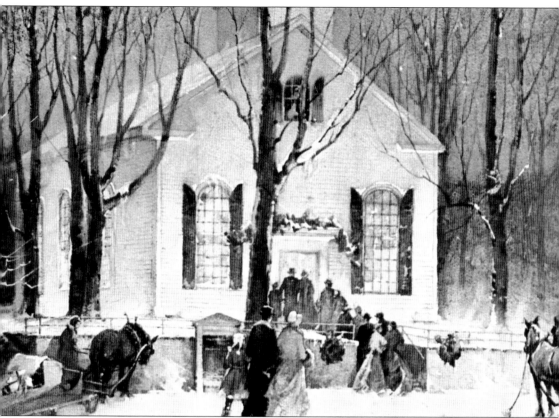

This 1960s postcard features another artist's rendering of Waterloo Village. Waterloo Church is depicted on a long-ago Christmas Eve. The person who purchased this postcard notes on the back that they visited the village during a field trip in 1968. The Waterloo United Methodist Church was built in 1859, and, surviving the ebbs and flows of the life of the village, celebrated its 150th anniversary in 2009. Even while Waterloo Village was shut down, Waterloo United Methodist Church, privately owned, continued to operate unceasingly, and it maintains an active congregation. Congregants displayed a similar dedication in the church's first years, with members originally meeting in the general store before the building's construction. In the small cemetery at the church, many of the plots date from the 19th and early 20th centuries. (Author's collection.)

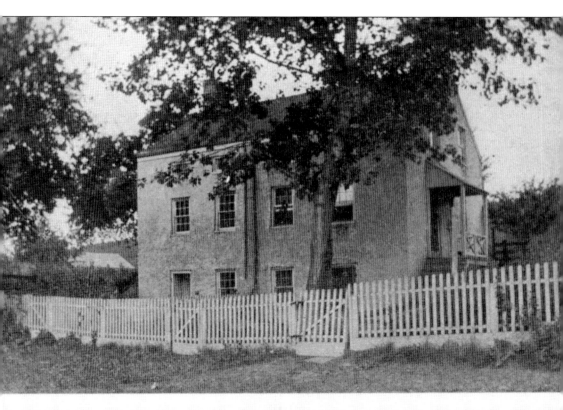

Stone House a Century Old, Waterloo, N. J.

At the time this postcard was sent in 1910, the Waterloo home depicted on the front was over 100 years old. This structure is on Waterloo property today and requires refurbishment. At the time the postcard was mailed, the canal had not yet been formally abandoned. After the canal ceased to be used, the village became deserted in the 1930s. However, squatters stayed there through the 1940s and protected it from vandalism before it was first officially preserved. The sender of the postcard explains that they are actually staying in the home and that their brother is a resident of the house. The stone buildings in the area, like this one, were constructed of rock native to Sussex County. The recipient of the card lived in Stroudsburg, Pennsylvania, and learned that Waterloo was "quite a nice place," based on the sender's account. (Courtesy of Wayne McCabe.)

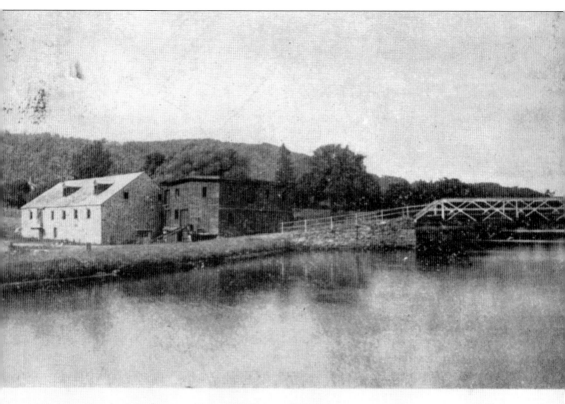

Grist, Plaster and Saw Mills, Waterloo, N. J.

Old Andover was Waterloo's name when the Smith family settled in and opened their general store. The name changed once it became a prominent stop along the Morris Canal in 1831. As parts of a functional and thriving canal town, the gristmill, plaster mill, and sawmill dotted the landscape. Eventually, these three buildings were refurbished or reconstructed. The original sawmill, featured on this postcard, burned down in 1917. The reconstruction of that building, as conceptualized by one of the two visionaries, Lou Gualandi, was modeled after an old barn. The gristmill itself was erected around 1760. The group Friends of Waterloo Village recently raised funds to repair the mill's roof. The mule bridge adjacent to the mill, which led to the inclined plane within the village, requires repair. The sender of this card mailed it from Madison, New Jersey, to a recipient in Pennsylvania. (Courtesy of Wayne McCabe.)

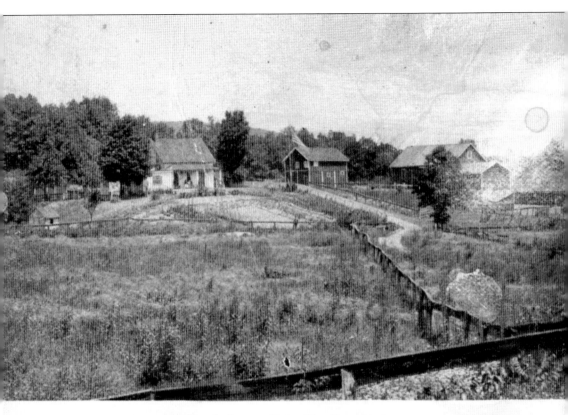

The Jefferson Club, Waterloo, N. J.

This postcard from 1910 is postmarked "Waterloo." Now known as Smith's Store, the store was the post office around the time this postcard was sent; A.L. Cassidy was the area's postmaster. The content of the postcard reflects the times, as the sender asks the recipient, of Deckerstown, New Jersey, who is obviously meeting for a transaction, "do not come for wagon until Tuesday." At this time, it was a different life in Waterloo, which lost the bulk of its population when the Delaware, Lackawanna & Western Railroad terminal switched to Stanhope and Waterloo became more barren. After the village's abandonment, then revival, then shutdown again, the New Jersey Department of Environmental Protection assumed responsibility. It has reopened on a limited basis for tours and is part of the Allamuchy Mountain State Park in Byram. (Courtesy of Wayne McCabe.)

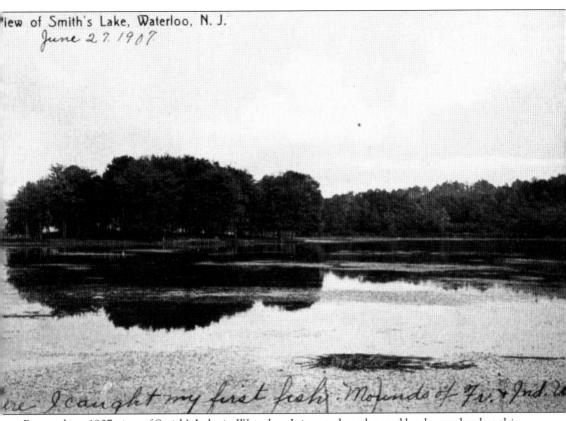

View of Smith's Lake, Waterloo, N. J.
June 27 1907

ere I caught my first fish. Mounds of Fr. + Ind. W

Pictured is a 1907 view of Smith's Lake in Waterloo. It is noted on the card by the sender that this is "where I caught my first fish" and "mounds of Fr. and Ind. Wars." The lake, which is now referred to as Waterloo Lake, was likely named Smith's Lake, after the owners of the land surrounding the lake at the time, headed up by Seymour Smith. During the time of the French and Indian War (1756–1763), settlers were often under attack by American Indians, including the Lenape, which had a strong presence in the county. In 1876, Seymour Smith reported to the *New Jersey Herald* that an Indian burial ground was adjacent to the water. A portion of this burial site was on the island in the lake. Excavators discovered several graves with relics from the 18th century. Today on that island is the Lenape Village of Winakung ("Place of Sassafras"), a restored section of Waterloo Village, which serves to teach visitors about the life of the Lenape Indians. (Courtesy of Wayne McCabe.)

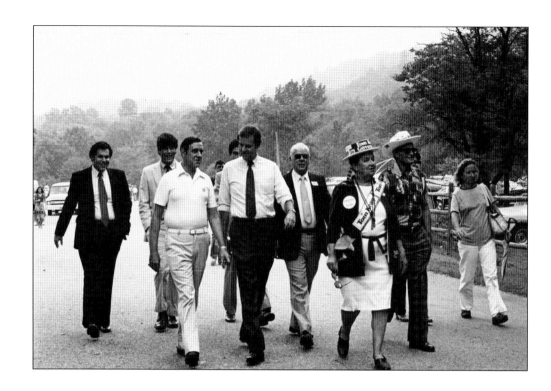

Above, New Jersey state assemblyman Tom Kean (front and center) walks with supporters through Waterloo Village while on the campaign trail for governor in 1981. Kean had been friendly with Percy Leach, part of the team instrumental for Waterloo's revival. Some controversy occurred in the late 1980s, with Governor Kean's approval to sell a portion of Allamuchy Mountain State Park for the construction of BASF's headquarters in the nearby International Trade Zone, in an effort to keep the company's North American headquarters in New Jersey. At the time of the future governor's visit to Waterloo, the venue was a destination for premier concert events, including Lollapalooza. Shown below is an unused ticket that the author won on a local radio station. Paula Abdul, known later as an *American Idol* judge, cancelled her appearance due to an injury. (Above, courtesy of Wayne McCabe; below, author's collection.)

Five

RECREATIONAL POINTS OF INTEREST

Sun glimmers on partially frozen Lake Lackawanna on a late winter's day in 2014. Lake Lackawanna became one of the area's vacation resorts at the turn of the 20th century, after the Lackawanna Cut-Off passed through the area and a dam was constructed to accommodate the railroad in 1911. From this, Lake Lackawanna was born. (Author's collection.)

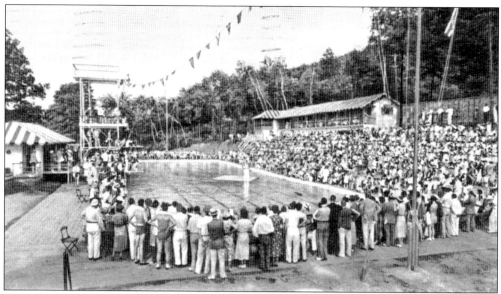

Though its location is labeled as Sparta, the Lake Mohawk Pool, formerly known as the Marine Pool and the Cruiser Club, is within the Byram section of Lake Mohawk. The five-acre setting, with an Olympic-sized pool and tennis courts, was constructed in 1937. The Marine Pool was modeled to resemble the deck of the luxurious SS *Normandie*, the fastest cruise ship of the 1930s. It was the first pool to use ozone rather than chlorine in its water treatments. Because of its amenities, the pool became a popular venue for swim competitions. Famous visitors, including swimmers Buster Crabbe and Esther Williams, were among the pool's guests in the 1940s and 1950s. Families have enjoyed the facilities since that time, though there have been lulls and transitions in management. New homes are currently planned at the site of the tennis courts. (Both, courtesy of William Truran.)

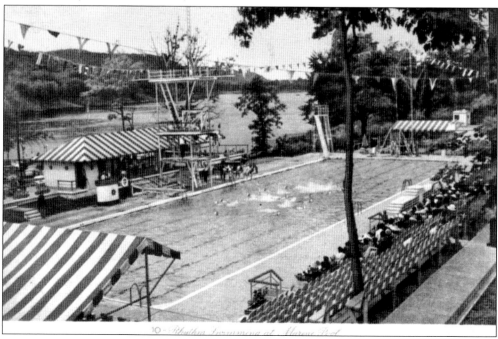

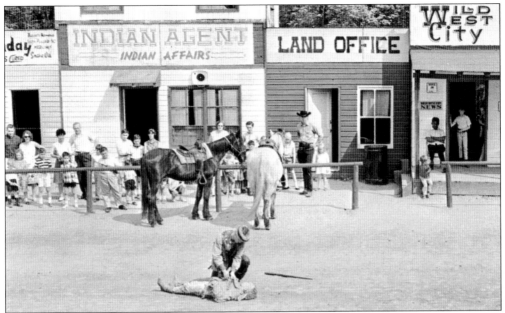

In 1958, an idea was conceptualized to provide entertainment to locals and visitors from the city areas, similar to what had existed in the earlier part of the 20th century. The goal was to continue to accent the Sussex County area's tourism aspects. Theme parks were one way to achieve this goal; thus, Wild West City was born. Investors purchased land and created a replica of 19th-century Dodge City, Kansas. Live-action shows (above) featuring characters such as Wyatt Earp have taken place there since. The below photograph depicts immersion into American Indian culture at the park. Posing here are members of the Big Mountain family, an Apache family that performed worldwide, including at Wild West City and at Carson City and Indian Village, a similar park in the Catskills area of New York State. (Both, courtesy of Wayne McCabe.)

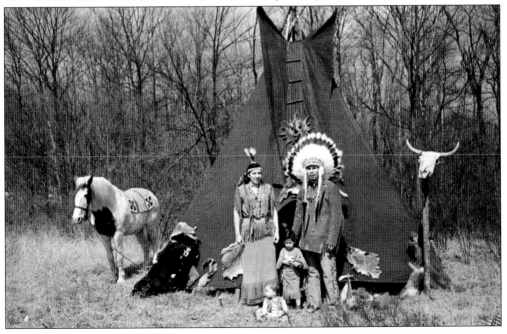

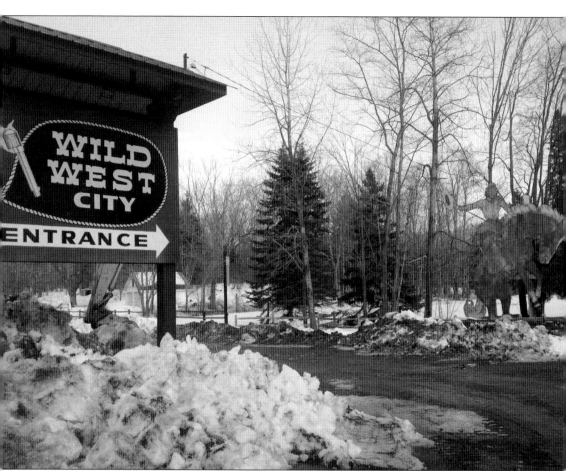

Wild West City's front entrance is seen here in March 2014. The park offers visitors a hands-on experience of life in America from the 1860s to the early 1900s, including panning for gold, riding a train or stagecoach, and learning about how cowboys and Indians lived. The park, however, has experienced some controversy after one of its actors, Scott Harris, was permanently injured when live ammunition, instead of blanks, was inadvertently used during one of the staged gunfights. In 2006, Harris was playing Wyatt Earp, as he had for years, and was hit with a bullet during one of the reenactments. He was partially paralyzed. Since then, the park has been challenged to revamp its firearm safety procedures and pay fines for unlawful possession of a handgun without a carry permit. A civil lawsuit is currently pending, with compensation sought for Harris's injuries. (Author's collection.)

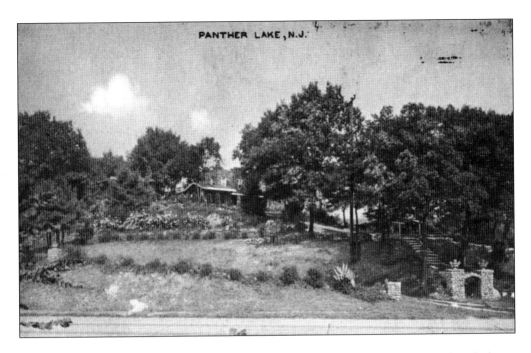

Panther Lake, a resort with a Byram Township mailing address, is technically classified as a portion of Andover Borough, Byram's neighbor to the north. The above postcard offers a view of a stone house, still currently located on Route 206 at the corner of Rose Marie Lane. The house is nestled into the woods and overlooks the lake, though it is located further north of the campground's current main entrance. The sender of the postcard shown below, Chas, writes, "Dear friend, this is the lake I am going rowing on this afternoon," in a note mailed in 1905. (Both, courtesy of Wayne McCabe.)

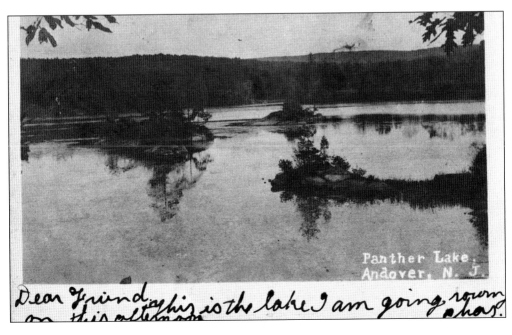

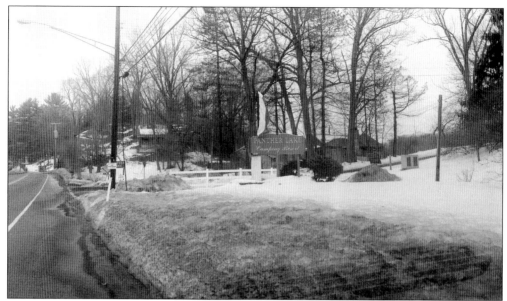

On this page are March 2014 photographs of the Panther Lake Camping Resort area. The campground's main entrance is shown above. In the below photograph is the stone building seen on the previous page, which today is shrouded by more trees. Panther Lake's history stretches from before the turn of the 20th century. The lake, which is 45 acres, is situated on 160 acres of property. As Chas was able to engage in row-boating in 1905, individuals and families more than 100 years later can still enjoy activities around the lake, such as fishing and boating, and they can spend time in the pool. There are events planned on-site, and sports such as basketball, tennis, miniature golf, and horseshoes are other options. In addition to campsites, guests can rent cabins and trailers on the grounds. (Both, author's collection.)

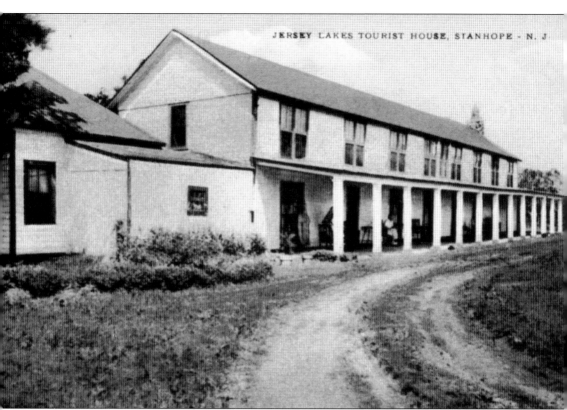

At the Jersey Lakes Tourist House, another recreational property of the past, guests could stay and access all of the local attractions. The facility, boasting 25 rooms, was located on State Route 31. Its spot was formerly across from where the Byram Diner is located, on the corner of Waterloo Road and Route 206 in Byram Township. It was razed in the early 1960s to make way for what has been described as a "colonial-style" gas station. As the postcard names the road as Route 31, it is dated prior to 1953, when the road name changed to Route 206. The postcard offers that area lakes are easily accessible to the venue. Byram Township, nicknamed "The Township of Lakes," had more than 24 lakes and ponds within its almost 23 square miles. There were plenty of options for visitors to choose from. (Courtesy of Wayne McCabe.)

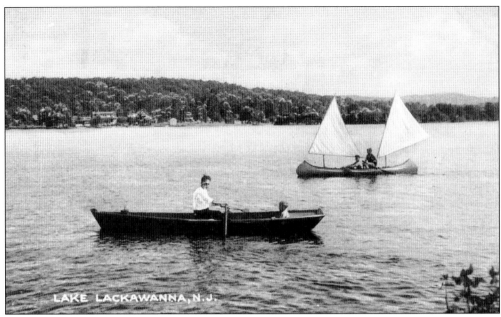

Shown above is a picturesque postcard of scenic Lake Lackawanna, mailed from Stanhope (where the card was also published) in October 1946. The sender, Dot, writes to her friend Anne in Massachusetts: "Best regards from Jersey—are here for a week with Judith." The postcard depicts a rowboat and a canoe with sails on it. Boating is one of the many activities still enjoyed at Lake Lackawanna today. Golfing is another, as pictured below. The Lake Lackawanna Golf Course, a nine-hole public course, opened its doors to the community in 1924, offering affordable golfing on a quality green. The course is situated within the neighborhoods, and some rank its caliber as similar to those of private golf courses. It is considered an executive course because of its smaller size, permitting players to enjoy a shorter game over lunch. (Both, courtesy of Wayne McCabe.)

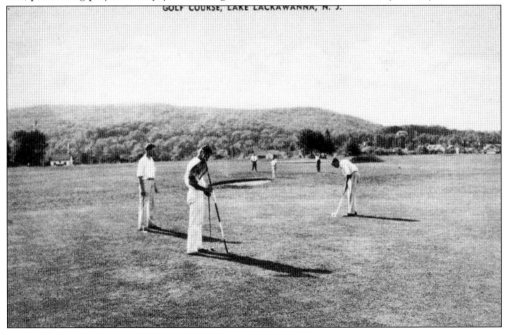

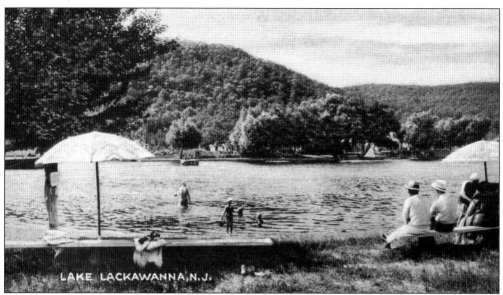

LAKE LACKAWANNA, N.J.

These two photographs offer a glimpse into life at Lake Lackawanna many years ago. Above, people enjoy a day at the beach. Bob Donlan, who spent time in the area growing up, is shown below on his family's dock in 1967. When built as a neighborhood, Lake Lackawanna was advertised as a place with "Every Sport of the Water, Every Thrill of the Woods, The Atmosphere of the Mountains." Homes started at $150 in the early days, with $25 permitted as down payment. The lake area, now mostly a year-round community, is one of the special places that Byram residents proudly call "home." (Above, courtesy of Wayne McCabe; below, courtesy of Bob Donlan.)

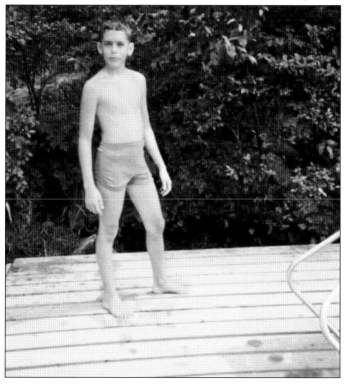

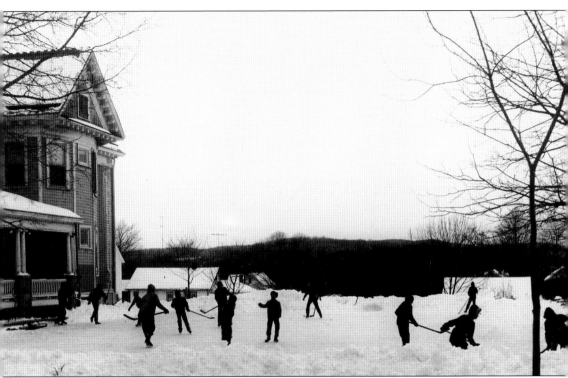

In the winter months in Sussex County, outdoor activities like hockey and ice-skating are enjoyed at the local lakes and ponds. In the past, improvisation ruled the day, such as when the Salmon family owned the spacious home at 110 Main Street in Stanhope that is now the Whistling Swan Inn. What is now the inn's garden was a section of the family's yard, which they flooded in the wintertime and allowed to freeze to a glassy surface. Local children were invited by the family to skate or, when it was scheduled, to play hockey. Such an occasion is seen here in the early 1960s, when Stanhope's children participate in a hockey game on the lawn. Many locals fondly remember the generosity of the Salmons, who lived there from 1941 through 1966, in hosting the winter extravaganzas. They also recollect the strict rules that existed during the recreational time; those who did not follow the rules were asked to leave and not return. (Courtesy of Ros Bruno.)

Six

INTERESTING PEOPLE AND PLACES

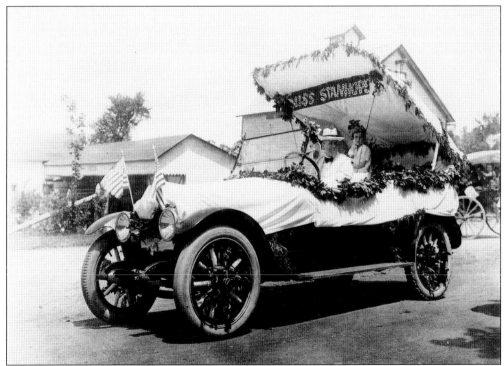

Who does not love a parade? Here, Miss Stanhope is paraded in an automobile adorned with decorations in the early 20th century. Pageants originated in New Jersey's Atlantic City in 1921 to attract and maintain tourism, commencing the Miss America tradition. Stanhope has its own history in that competition: resident Alicia Luciano, Miss New Jersey 2002, placed 19th overall in the 2003 Miss America pageant and ranked third in the gown competition. (Courtesy of Ros Bruno.)

Young Daniel Sutton poses on a Byram roadside in the 1920s. This determined-looking little boy eventually paved the way for the founding of the Lakeland Emergency Squad as a teenager in 1939. The first squad was organized in his parents' store, the Cliff Inn. Only a few years later, Sutton served his country during World War II in the US Navy, stationed on a destroyer and minesweeper in the war. He was part of the Bougainville campaign's first phase in the South Pacific, to recoup the island from the opposition, and he participated in squadron raids on the Gazelle Peninsula in New Guinea a month later. After returning to Byram, Sutton received the honor of his name on the township's honor roll. He was one of the original police officers on the Byram Township Police Department, formed in the 1930s. It became a full-time department in 1971. As a part-time officer, Sutton drove the family's Ford Country Squire station wagon, which became one of the township's first police cars. (Courtesy of Daniel Sutton.)

The Roseville Tunnel was a marvel created between 1908 and 1911 to make way for the Delaware, Lackawanna & Western Railroad's Lackawanna Cut-Off. The 1,024-foot, two-track tunnel was bored through unstable rock. Trains still passed through the tunnel in the 1960s, when Winnie Testa (Slachetka) posed in front of it with her brothers Robbie (right) and Tom and their dog, Billie. She holds fond memories today of playing near the tracks with friends and leaving pennies there for trains to press and elongate. The below photograph, part of the Fred J. Stephens collection, shows a train roaring through the Roseville Tunnel around 1968. This photograph was taken from a similar vantage point as that of Winnie and her siblings. (Right, courtesy of Winnie Slachetka; below, courtesy of William Truran.)

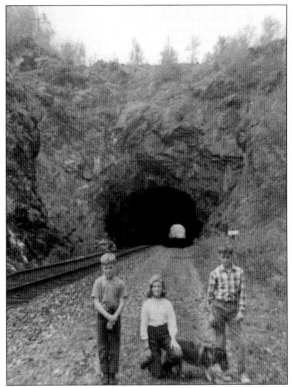

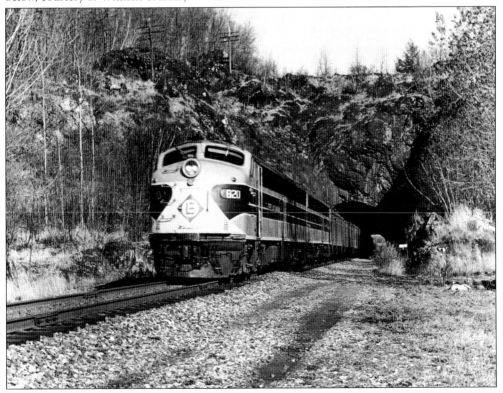

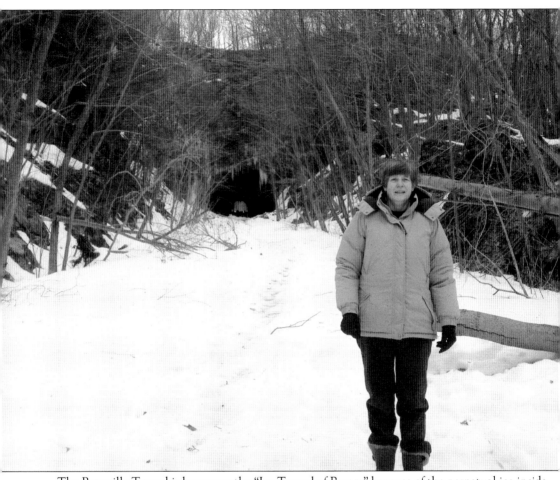

The Roseville Tunnel is known as the "Ice Tunnel of Byram" because of the perpetual ice inside of it. Here, Winnie Slachetka poses in March 2014 in a similar place as she did in the 1960s photograph on the previous page. Mammoth icicles dangle on the exterior of the tunnel, in the background. Rock has dropped in the middle of the tunnel, seen even from a distance, and either side of this route on which trains once traveled is now overgrown with trees. Originally planned to be a small, 140-foot cut into the rock, the tunnel's dimensions were changed when workers on the project realized the rock, a type of granite, was too volatile. More than 35,000 cubic yards of rock were removed to create a sturdy passage. The area has been reinforced over the years due to sliding rocks. The tunnel was opened officially on December 24, 1911, and it serviced the Erie Lackawanna Railway. Service was discontinued in January 1979, and the tracks were lifted in 1984. The tunnel is planned for use again when New Jersey Transit passenger rail service is reinstated around 2016. (Author's collection.)

These photographs show Byram students around 1966, prepared for sports and school. Shown above are members of the 1966 league champions, the Andover Arrows, a team previously known as the Lackawanna Fireballs. Mike D'Angiolilli (no. 83) is in the second row, second from right. Members of the winning team remember their coach, Buddy Jackson, with fondness. He expected players to address adults with "Yes" and "No," "Sir" and "Ma'am." Jackson did not have children on the team, but he volunteered his time to coach. In the below photograph is Byram School's 6D class of 1966. Winnie Testa Slachetka is in the second row, far right. Alumni from the school recollect their teacher, Mr. DiMarco, and some have seen him from time to time, even recently. (Above, courtesy of Mike D'Angiolilli; below, courtesy of Winnie Testa Slachetka.)

These Byram School photographs show students and teachers from class 5C in 1965 (left) and class 8A in 1969 (below). The fifth-grade teacher is Mrs. Crawford. Winnie Testa Slachetka, who provided the photograph, is in the third row, second from the left. The eighth-grade teacher is Mr. Anderson. In this class photograph, Winnie is in the first row, second from the right. Anderson was the science and shop teacher. In those days, the Byram Consolidated School, built in 1936, housed kindergarten through fourth grade. It has recently been proposed for rezoning, for redevelopment into an apartment complex. Grades five through eight were in the intermediate school. Students attended high school at either Pope John or Sparta. Sussex County Technical School and Lenape Valley Regional High School did not exist. (Both, courtesy of Winnie Testa Slachetka.)

In 1982 and 1983, members of the Byram Township Fire Department, then known as the Cranberry Lake Volunteer Fire Department, participated in two events at the Sussex County Farm and Horse Show, now a part of the New Jersey State Fair. In 1982, members of the fire department's ladies auxiliary participated in a hose-laying contest, with Cranberry Lake the champs (above). The following year, the auxiliary was there again at the Sussex County Fairgrounds for the bucket brigade (below). Local fire department competitions wrapped up the fair festivities. Fred Fry was fire chief from 1981 through 1983, when these photographs were taken. He and his wife, Pat, were involved in the community. Pat was a member of the ladies auxiliary before the family moved to Texas in 1984. (Both, courtesy of Fred Fry.)

Jason Fry, the little boy in uniform in the above photograph, marches in front of his father, Fred Fry (in white hat), in a 1982 Memorial Day Parade. In the left photograph, at a 1980 Memorial Day event, Freddy Fry plays "Taps" on his trumpet at a ceremony concluding the parade, on the Cranberry Lake Bridge. His father, Fred Fry, is pictured next to him, saluting. Jason was born Memorial Day Weekend of 1974 and remarked about his mother Pat Fry's dedication to the auxiliary: Though in labor, she continued assisting with the festivities. To the chagrin of the Lakeland Emergency Squad, Pat waited until the end of the day and then proceeded to the hospital. (Both, courtesy of Fred Fry.)

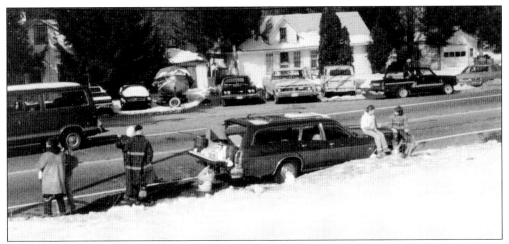

Pat Fry's station wagon, pictured in these 1983 photographs, was often spotted at large-scale emergency calls as a way to cart food and drink to the scene on behalf of the ladies auxiliary and to assist the firefighters. Fred and Pat Fry were involved with the fire department for 20 years before relocating to Texas. Other families with deep roots in the community as well belonged to the department. Daniel Sutton, of whom several childhood photographs are featured in this book, was also fire chief, as was C.O. Johnson, Byram's longtime mayor, for whom one of Byram's parks has been named. (Both, courtesy of Fred Fry.)

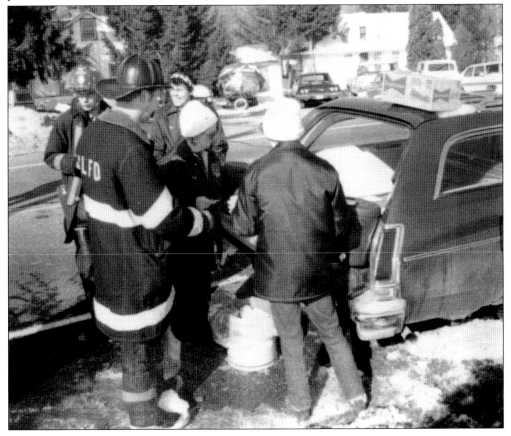

When Jason Fry's son was born in 2010, there were difficulties in choosing a name for the baby. Jason's older sister suggested naming him after the town where they lived. It was then that Jason decided that, if his son would be named after any town, he would be named after his former hometown, which is still dear to his heart, Byram Township. His son, born a few days after the New Year in 2010, was named Byram Fry. The above photograph was taken in June 2011 in front of Rescue Truck 3. When Byram returned with Jason to Byram in 2013, he was excited to learn that his name was on the front of the fire department building. He is shown below in front of the fire department building on Route 206. (Both, courtesy of Jason Fry.)

Byram Fry sports his own set of Byram fire department gear. The Byram Township Fire Department was organized in 1948 in the Tamarack Inn and was then known as the Cranberry Lake Volunteer Fire Department. The department is now split between three firehouses, including the building by Cranberry Lake along Route 206, the building near Lake Lackawanna, and the third in Byram's Lee Hill section. The department, which started with two engines, has grown to three engines, two tenders, and one rescue truck. The department was built on fundraising, including bingo games, clambakes, and parties throughout the year hosted by the fire department. (Both, courtesy of Jason Fry.)

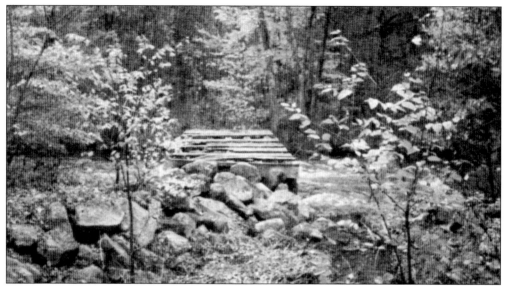

The White Bridge is seen above in 1984. In 2013, Byram and Jason Fry, pictured below, pose at the bridge's site. The bridge, still intact in 1984, was located in the former neighborhood where Jason resided with his family on Beech Street, in the West Brookwood section. The neighborhood borders Stanhope Borough and is located near where Route 206 splits and Route 183 forms. Where River Road and Belton Street meet, at one time, one could cross the Musconetcong River via the footbridge, which has now mostly disappeared. Other residents recall the bridge and memories of playing around it. A petition was created in this quiet neighborhood to close off a portion of Belton Street, so that neighborhood children could sled down a large hill during one snowy and icy winter. (Both, courtesy of Jason Fry.)

The Frogmore Country Store was a friendly stop along Route 206. David Thompson and George Haddad were its proprietors. The above postcard hails from the 1970s, after the *New York Times* published a 1972 story featuring the location. The store was to the left, and a home was at right. Bill and Liz Clinton owned the building, as well as the Cottage Restaurant in Andover Borough and, later, the Liz Clinton Boutique, still open today as the Wedding Store. Frogmore in its day was known for antiques and old-fashioned items, including candles, candies, and soaps. The author's mother, one of the consignors in the 1970s, sold bread-dough ornaments and sometime helped in the store. The author holds fond memories of David, George, and their dog, Hildie. Frogmore Country Elegance is seen below in its expanded location today. (Both, author's collection.)

ADVANCE MATCH & PRTG.CORP.
CHICAGO,ILL.,MADE IN U.S.A.

THANK YOU CALL AGAIN

Murph & Billie
Bar & Grill

Route 31
Stanhope, N. J.
Where All Friends Meet

Institutions from days past are represented on this page. The Byram Motel (above) was an establishment situated on Route 206, parallel to Brookwood Road and diagonal to Waterloo Road. The motel, demolished around 2009, was in proximity to the Byram Diner. The relic at left is a matchbook cover from Murph & Billie Bar & Grill, an establishment located in the area as well. The matchbook dates to before 1953, when Route 31 transitioned to its new name, Route 206. (Above, courtesy of Bob Donlan; left, author's collection.)

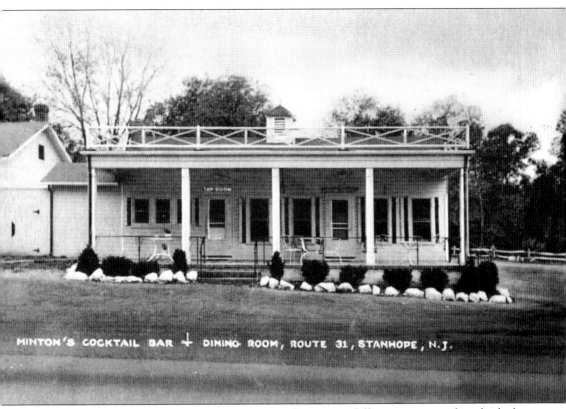

MINTON'S COCKTAIL BAR + DINING ROOM, ROUTE 31, STANHOPE, N.J.

Minton's was another beloved venue in the area, boasting a full-course menu of steak, duck, chicken, and seafood dinners. Though listed on the front of the postcard as Stanhope, Minton's was located on Route 31, which is now Route 206, on property that is now Lynnes Nissan West in Byram Township. Based on the Route 31 address and the Netcong 101 telephone exchange (operator assistance was still required minimally until the 1960s), this card dates to before 1953. In Sussex and Warren Counties at the time, phone numbers consisted of the community name and a two- or three-digit number given to the operator. In November 1950, Minton's advertised this same address and phone number in the *Hackettstown Gazette*, promoting reservations for "your old fashioned Thanksgiving Dinner," with meals including "turkey, duck, squab, chicken and a variety of steaks." (Courtesy of Wayne McCabe.)

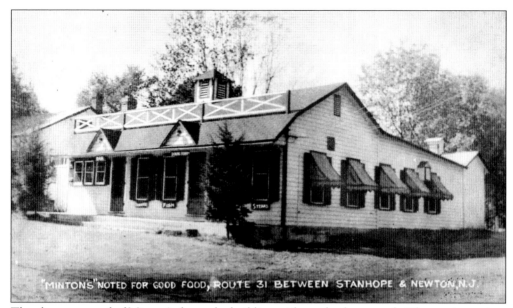

The above postcard of Minton's shows the building without the front porch. The caption points out that the establishment is "noted for good food." The location given is more precise than on the postcards on the previous page—"between Stanhope & Newton, N.J." On the postcard shown below, the restaurant advertises a cocktail bar and dining room. Minton's made the local papers for events it hosted. The *Hackettstown Gazette* announced several wedding receptions at the establishment, including those of Mr. and Mrs. Thomas Workman (née June Mayberry) in 1952, Mr. and Mrs. Thomas Wydner (née Laurene Ader) in 1961, and Mr. and Mrs. Phillip Schomp (née Marion Dilley) in 1962. The retirement party for Hackettstown High School teacher Emily Johnson in 1952, the newspaper reported, was also at the restaurant. (Both, courtesy of Wayne McCabe.)

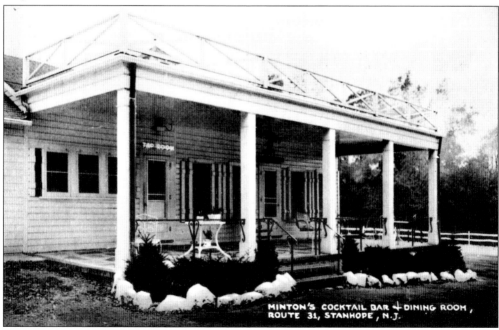

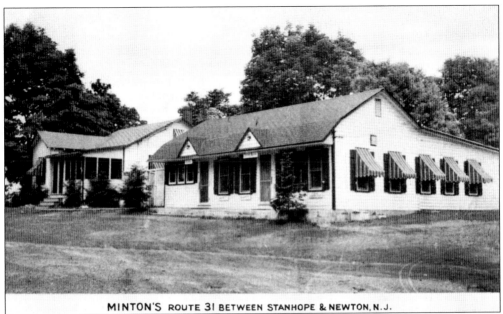

MINTON'S ROUTE 31 BETWEEN STANHOPE & NEWTON, N.J.

Before Minton's boasted air-conditioning in later real-photo color postcards and showed views of its expansive dining room and long bar with green chairs (matching its green carpeting), a young woman named Gail mailed this postcard from Netcong to a friend in East Orange. This postcard reflects charm, with the stamp and postmark placed at the lower right, as well as the childlike penmanship of the writer. In 1943, in the midst of World War II, Minton's was advertising spaghetti and fish and chips on its menu. Following Minton's closure, it was named the Search Light and the Rock Pile. Now, the site is home to Lynnes Nissan West. The five columns of the dealership's front porch are the only recognizable trace of Minton's today. (Both, courtesy of Wayne McCabe.)

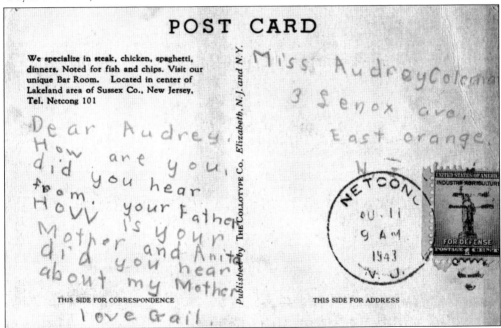

The Stone House Restaurant was another establishment of days past on Route 31. It boasted full-course dinners, steaks and chop, sandwiches, and Hershey's ice cream. The site of the Stone House, 109 Route 206 South in Byram, is now home to Salt Gastropub, which has established itself as an upscale, popular eatery and music venue. Prior to Brad and Laurie Boyle assuming ownership of Salt, the restaurant was the 76'ers Waterloo Inn. This venue was a restaurant and later a dance club, under the company Stonehouse Inc., established in 1968. Though most of the stone front of the building is now covered with wood siding and brick, some of the original stone surrounding the front windows is visible, and the stone frame from the original structure's windows remains inside Salt's bar area. (Above, courtesy of Wayne McCabe; below, author's collection.)

76'ers Waterloo Inn

V.I.P.

Present this card when paying cash and receive,

10% OFF THE TOTAL BILL.

Dinners Only

(Banquets are excluded) **Phone: (973) 347-4000**

Shown above is a service station owned by W.F. Talmadge, which, as its claim to fame, served the "biggest and best hot dog in the world" and "largest ice cream cone in America." As indicated on the sign, this establishment endorsed Horton's. A customer could also gas up his vehicle with authentic Shell gasoline at the station, located on Route 31 between Stanhope and Newton, as many establishments' locations were listed. Shown below is Hanley's, a picnic grove in Byram, on the corner of Waterloo Road and Route 206, owned by George Hanley. According to his granddaughter Carlene Thissen, Hanley's was a speakeasy. Hanley lost his money and establishment following the Great Depression. It became the Red Wing Inn, Pier 206, and Bredbenners before it was torn down. (Both, courtesy of Wayne McCabe.)

X15 Picnic Ground Grove at Hanley's, Every Body Happy, at Stanhope, N. J.

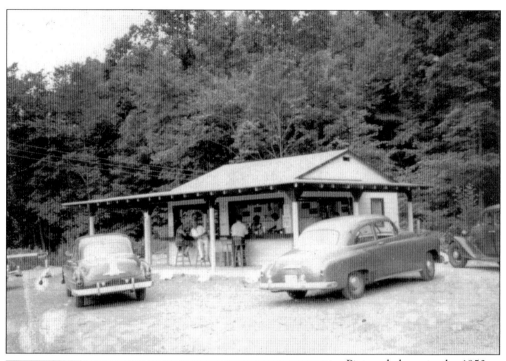

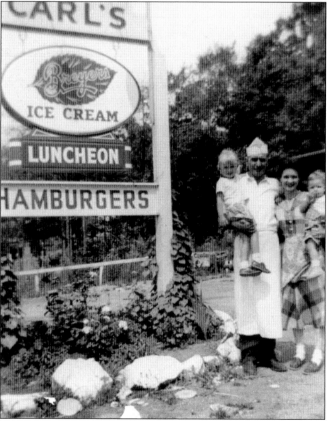

Pictured above in the 1950s is Carl's Hot Dogs, another beloved establishment in the area. The location was near the Cranberry Lake section of town. Carlene Thissen's father built the original stand. It occupied the site where the Mountainside Restaurant in Byram was located. At left, Thissen's family poses outside of Carl's Hot Dog Stand around 1955. The business then was located in what was called Cat Swamp Mountain. Carlene is in her father, Carl's, arms, and her sister Kathy is with her mother, Mary. Locals remember that Carl's, and many fondly remember Carl and Mary and the service the family offered to the community with their establishment. (Both, courtesy of Charlene Thissen.)

There was a second Carl's, pictured here. Carlene's mother, Mary, works the counter at the location on Route 206 and Tamarack Road in 1966. The establishment advertised pure beef hamburgers for a quarter, which, at less than $2 in today's currency, is still very affordable—in fact, less expensive than at most fast-food establishments. (Courtesy of Charlene Thissen.)

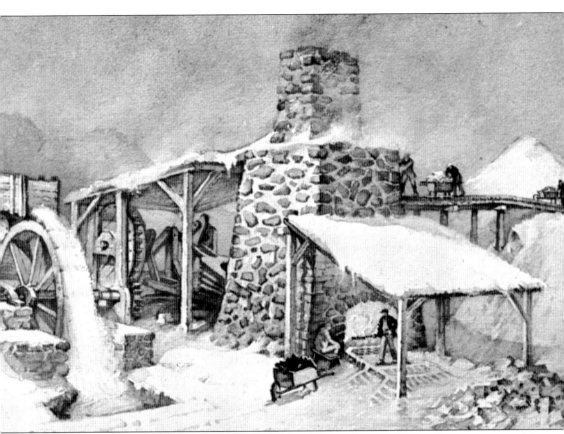

This is an artist's rendering of the Andover Forge. Before Stanhope and Byram became communities, cementing their places in the iron and mining industries respectively, their neighbor to the north, Andover Borough, became known for commencing the iron industry in the area. As early as the 1750s, the Andover Furnace generated what was reputed to be the finest iron in the world. In 1758, the Andover Iron Company was formed and acquired 4,287 acres in the area. Further acreage continued to be acquired around the vicinity that is Route 206 and stretching toward Cranberry Lake. From September through December 1760, the forge produced 332 tons of pig metal. The company constructed a gristmill and the ironmaster's house, both of which are still standing today. Controversy erupted over the ironworks when supplies were manufactured there to assist the British. The business was seized from owners William Allen and Joseph Turner for their loyalty to the Crown. Eventually, the operations would stretch into the Waterloo area, before the land was partitioned and sold in the early 1800s. (Courtesy of William Truran.)

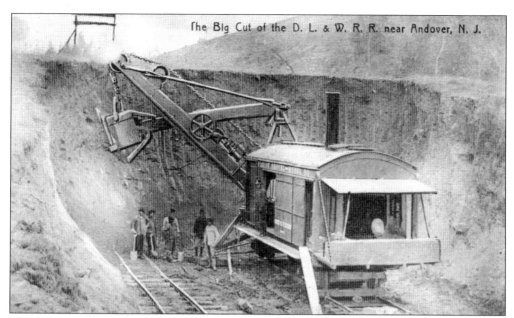

The Big Cut of the D. L. & W. R. R. near Andover, N. J.

These images depict construction of the Delaware, Lackawanna & Western Railroad in the Andover area. The stretch of the railroad in this area is known as the Lackawanna Cut-Off. Andover ended up as the location for three separate railroads: the Cut-Off, Sussex Branch, and Lehigh & Hudson River Railway. Construction began in 1908 on the nearly 29-mile stretch of railroad line through the area, from Port Morris by Lake Hopatcong to Slateford Junction by the Delaware Water Gap, with Andover Junction a major interchange. Once the Lackawanna line gobbled up portions of the Sussex Branch, it shuttled passengers just south of Andover to Cranberry Lake from city areas, and industry in the area received further support. Andover Township will be the home of the new passenger station planned for Roseville Road on the former Cut-Off. (Both, courtesy of William Truran.)

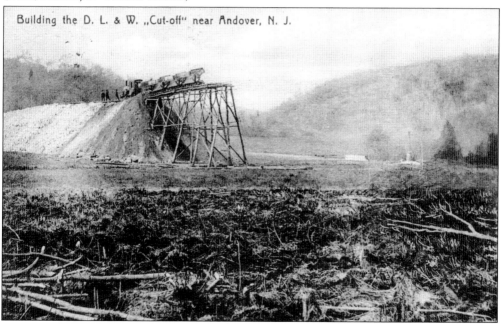

Building the D. L. & W. „Cut-off" near Andover, N. J.

Past and present are compared in these photographs of Stanhope and Byram's neighbor to the north, Andover Borough. The above photograph was taken by William B. Barry Jr. around 1930. The view looks down from what is today Railroad Avenue, onto tracks that paralleled today's Route 206. Shown below is the view today. The building at right is now a store, Made in the Shade. The structure on the left with the front porch houses apartments. Curiously, in both photographs, automobiles from the era are parked adjacent to this building. The building behind this one is Fancy Pants, a consignment store. Where the tracks once were is now a small driveway. (Above, courtesy of Steamtown NHS Archives; below, author's collection.)

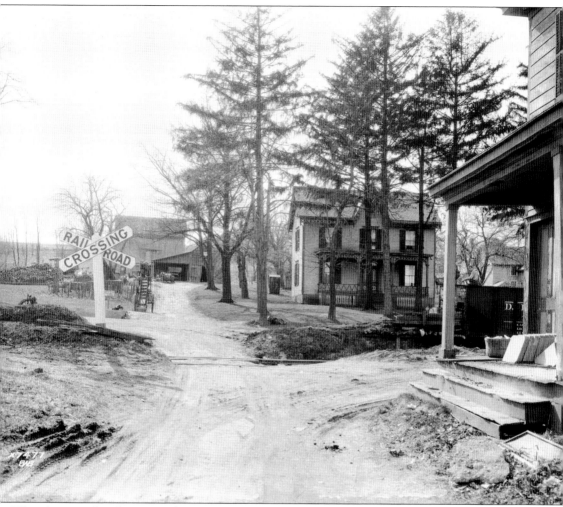

This photograph, taken in Andover Borough by William B. Barry Jr., shows the railroad tracks as they appeared around 1930, from the vantage point of what is today Fancy Pants. Beyond the crossing is the current Railroad Avenue. The house to the right and across from the tracks is still visible today. The barn in the background is still standing, as seen in the next image. (Courtesy of Steamtown NHS Archives.)

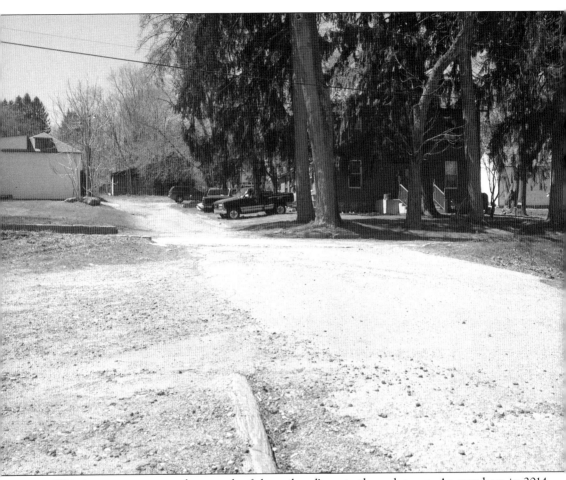

This is a contemporary photograph of the railroad's route through town. As seen here in 2014, trees have grown to the point that the house is mostly obstructed from view. The house shown in the previous image still stands, but it has been modernized. (Author's collection.)

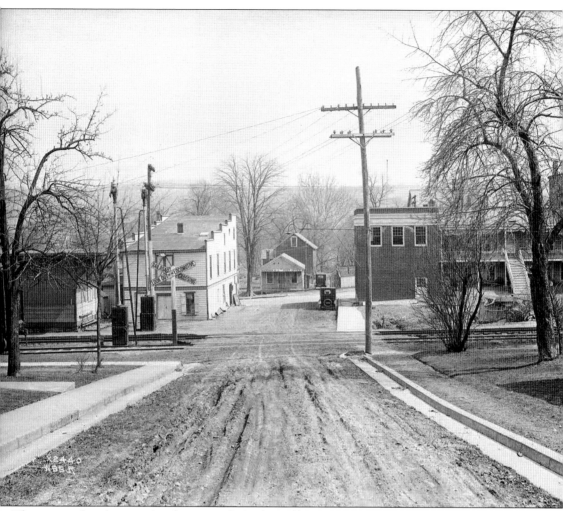

The view in this photograph, taken around 1930 by William B. Barry Jr., looks down Smith Street and across what is now Railroad Avenue, with a view of Main Street in Andover Borough, which is now Route 206. The brick building on the right with the three windows is now the Andover Borough Municipal Building. Upstairs is the Historical Society of Andover Borough and its museum. (Courtesy of Steamtown NHS Archives.)

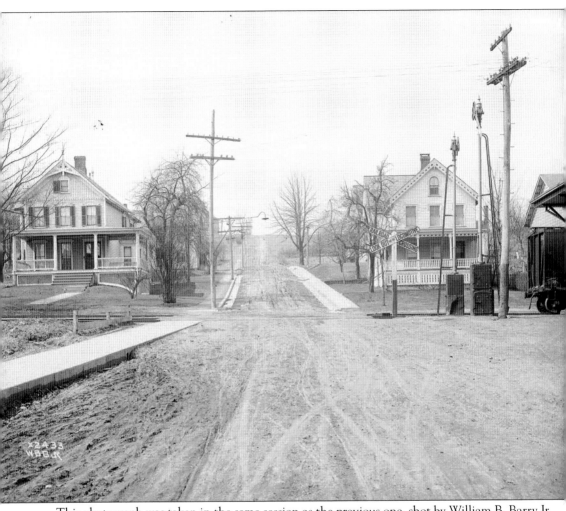

This photograph was taken in the same session as the previous one, shot by William B. Barry Jr. The view in this image, the inverse of the previous one, looks from today's municipal building and Route 206 and past the railroad tracks. (Courtesy of Steamtown NHS Archives.)

William B. Barry Jr. took this photograph around 1930, now in the hands of the Steamtown NHS Archives. He stood at what is today Smith Street, facing today's Railroad Avenue. Barry was behind the current location of Andover Borough's Municipal Building, standing where there is now a small parking area for those who may be visiting the municipal building or the historical society, or simply enjoying some antiques shopping in downtown Andover Borough. (Courtesy of Steamtown NHS Archives.)

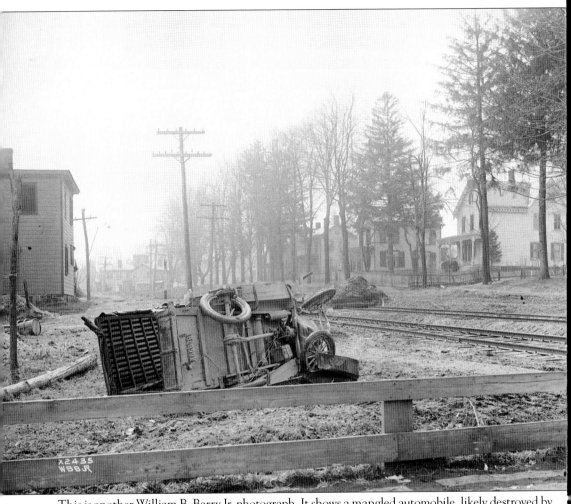

This is another William B. Barry Jr. photograph. It shows a mangled automobile, likely destroyed by a passing train. The wheels of the car are broken, showing the fragile nature of early automobiles. (Courtesy of Steamtown NHS Archives.)

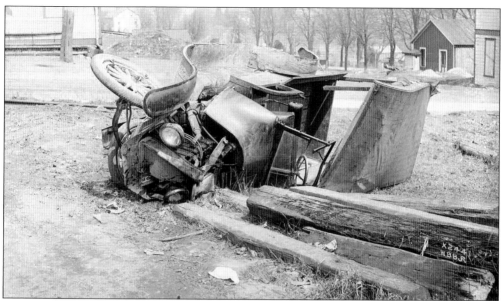

William B. Barry Jr. took these two photographs in Andover Borough. They are now in the keeping of the Steamtown NHS Archives. The above photograph shows a close-up of the totaled and abandoned automobile. The railroad crossing signs, depicted in previous photographs, warn drivers to "look out for the locomotive" at the crossing, a warning this motorist obviously did not heed. The photographer captured the view seen below around 1930, in the same series of photographs, across the street from the car, from the passenger station of the Delaware, Lackawanna & Western line, as can be seen by the abbreviation on the car at right. The view looking across what is now Smith Street toward current-day Railroad Avenue and what is now parking behind the Andover Borough Municipal Building. (Both, courtesy of Steamtown NHS Archives.)

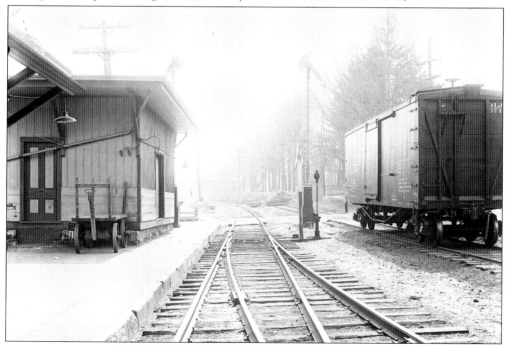

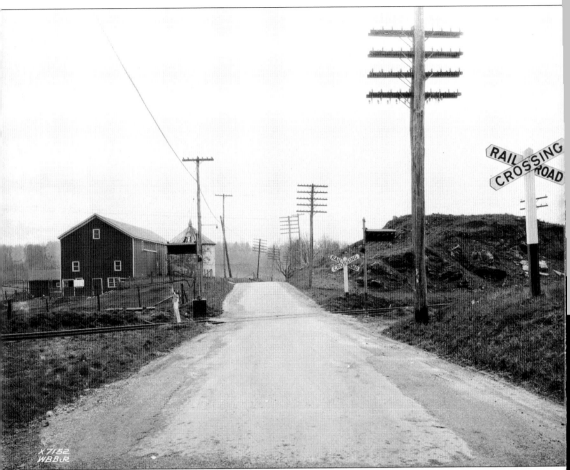

Standing on what is now Route 206 in Andover Township, William B. Barry Jr. would now be even farther north than Andover Junction, the station previously shown in the Andover Borough area. The tracks were located where the trail-crossing crosswalk is today on Route 206, north of where the Forest Fire Service Division Headquarters now stands. The silo's cylinder, at left in the distance, long remained without its roof but is now fully gone. (Courtesy of Steamtown NHS Archives.)

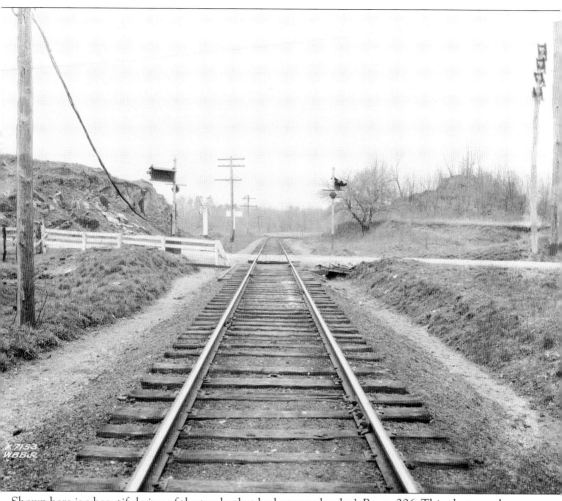

Shown here is a beautiful view of the tracks that looks toward today's Route 206. This photograph was taken by William B. Barry Jr. Note here the presence of telephone lines in the distance. (Courtesy of Steamtown NHS Archives.)

SOUVENIR POST CARD CO., NEW YORK.

3352 St. Patrick's Cathedral. Newark. N. J.

I am having a delight[ful] time. Hastly E. E. H.

Irving B. McPeak was a resident of the area from approximately the late 1870s, when he was born in the Mount Olive area, and lived in Mount Olive and later Succasunna. The census records from 1910 through 1930 that are available offer a snapshot into this local person's life. They show that he was a farmer. In the 1910 census, McPeak was approximately 32 years old and residing with his parents, William and Minerva. At that stage, he was a laborer on a horse farm. His father was 68 and still farming, as indicated by his listed occupation. Irving received the postcard during this period, in 1906, from a friend visiting Newark. The card depicts St. Patrick's Cathedral, which was built in 1846. It still exists today among high-rises and is in the National Register of Historic Places. (Both, author's collection.)

Post Card

THIS SIDE FOR THE ADDRESS

NEWARK 11 30 AM 1906

2 C

Mr. Irving Mc. Peak
Mount Olive
N. J.

In the 1920 census, Irving B. McPeak is listed again. This time, he is a married man in Mount Olive Township. Still a farmer, he resides with his wife, Lydia, and son Elmer, age seven. Irving now owns his own home. This Christmas postcard, mailed from Newark in 1920, offers a glimpse into life's quaintness in those days. "RD" indicates "rural delivery" as the family's address. In the 1930 census, Irving and his family are recorded in "Succasunna Village." Records show that Lydia McPeak passed away and was buried at the Presbyterian Church Cemetery in Succasunna in 1954. A November 1955 *Hackettstown Gazette* reports that Irving wintered in Florida and, in 1961, sold his home on 20 Eyland Avenue in Succasunna and its contents via auction. Records show that Irving died in Florida and is interred in the same cemetery as Lydia. (Both, author's collection.)

OF LOCAL HISTORY BOOKS

NS OF VINTAGE IMAGES

...al history publisher in the United States, is committed to making history accessible and meaningful through publishing books that celebrate and preserve the heritage of America's people and places.

Find more books like this at
www.arcadiapublishing.com

Search for your hometown history, your old stomping grounds, and even your favorite sports team.

Consistent with our mission to preserve history on a local level, this book was printed in South Carolina on American-made paper and manufactured entirely in the United States. Products carrying the accredited Forest Stewardship Council (FSC) label are printed on 100 percent FSC-certified paper.

MADE IN THE